My Father Hunts Zulus,
My Mother Puts Up Pickles

*6.10.02*

*For Jane,*
*with all good wishes on your*
*birthday,*
*Stella*

# My Father Hunts Zulus, My Mother Puts Up Pickles

*stories*

Stella Zamvil

2001 · FITHIAN PRESS, SANTA BARBARA, CALIFORNIA

Some of the stories in this collection were first published in the following periodicals: *Greensboro Review, Hoosier Challenger, Jewish Dialog* (Canada), *Jewish Digest, Harpoon Alaska,* and *Foothill Foreground.*

Published by Fithian Press
A division of Daniel and Daniel, Publishers, Inc.
Post Office Box 1525
Santa Barbara, CA 93102
www.danielpublishing.com

LIBRARY OF CONGRESS CATALOGING-IN-PUBLICATION DATA
Zamvil, Stella, (date)
    My father hunts Zulus, my mother puts up pickles : stories /
by Stella Zamvil.
    p.   cm.
    ISBN 1-56474-377-2 (pbk. : alk. paper)
    1. Jews—United States—Fiction.   I. Title
    PS3576.A48 M9 2001
    813'.54—dc21
                    00-012884

*To friends and teachers*
*who have been so helpful,*

*and to my daughter, Linda,*
*always a staunch supporter*

# Contents

My Father Hunts Zulus, My Mother Puts Up Pickles: 11

A Time of Indecision: 28

Was Last Night the Party?: 38

The Funeral of Myron Teitz: 42

Tante Lena: 47

Frimme Gittel's Encounter: 55

Medicine: 65

Encounter: 78

Tabby: 83

The Day They Ran Out of Doors: 88

And There Was Esther: 92

Sweet Charity: 97

What Friends Are For: 104

The Woman Who Fell from the Sky: 113

Reb Yonkel: 126

Tell Them I'm from Brooklyn: 132

Mrs. Ringer's Guest: 139

Go and Begone: 145

My Father Hunts Zulus,
My Mother Puts Up Pickles

# My Father Hunts Zulus, My Mother Puts Up Pickles

I T WAS A LONG DAY a long time ago. We had wasted no time getting up that morning. It was moving day. The first of many it turned out to be. The boxes packed the night before, square and rectangular cartons, stood near two barrels which contained all our glassware and dishes. Some clothing had been crammed into our old trunk; some still hung in the closet waiting for cardboard clothing receptacles.

It wasn't a long-distance move—really a short one, just next door practically. But the preparation, the packing, was identical.

Constantly we waited on the verge of leaving. Four

scheduled moves in four weeks had been cancelled at the last moment. A trucker's strike, moving van breakdown, the moving crew hit by Asian, African, or Russian flu. The last equally inane excuse flew over my head. All I remember is Mama on the phone taking the message as we sat dressed and waiting for the movers. We gave up and went to school.

For a short time we had even considered bringing some of the things from the old apartment to the new by ourselves, but after running down three flights of stairs, walking half a block, and then up another three flights with hands full of paired and unpaired shoes, Mama decided we should pay the difference and let the movers do the whole job, evacuating the apartment with one fell swoop and sweep—boxes of books, beds, dressers, dish barrels, clothes, even our tired toys stuffed into a cardboard box.

The kitchen would have to be unpacked first. Maybe not for dinner that first evening after the move; we had already envisioned a snack in the neighborhood lunch wagon. But this was pickling season—rather almost tail-ending it now. The impending move had kept us from picking up the gherkins and dill earlier, wanting to use them fresh immediately after their daily delivery to the market's fruit and vegetable stands; otherwise the pickles would become soggy, gum-soft rather than the snapping crisp pickles mother was known for and which we gobbled with every meal—every meal except breakfast, of course. It was a jar of these pickles in a brown bag that Mama brought whenever we were invited to someone's house for dinner. Sometimes, the way they made over them, sometimes I even think we were invited because of them. So the pickle jars, caps, and spices were packed with the greatest of care and marked with deliberate exactness for

special handling and placing. A lost day or two, the delay in getting the market's last batch of four lugs of gherkins as they were trucked in from upstate New York to the local supermarket could, would cost us six months of pickles! Destitution! Forced to eat store-bought dills!

So moving day was synchronized with an eye on the number one gherkin. We had thought of setting them earlier, but the jars had to stand upside-down for twenty-four hours and be watched for leakage. That might be stretching a new or old neighbor's neighborliness to let one hundred and twenty one- and two-quart jars sit on their kitchen counters, on boxes, under sinks and cupboards, or in the bathrooms. And Mama shuddered at the thought of her pickles fermenting in other hands, before alien eyes. What would happen if a jar lid loosened? She checked them in the night during that crucial twenty-four-hour period. After the jars were turned right-side-up and the serious fermenting had begun, when jar tops inevitably gave a bit, would— could—she ask the neighbor to let her in to tighten her pickles? Ah! Foolishness! Such foolishness they would say. A mish mash over pickles.

Unfortunately the gherkins in the market ripened without the preconsideration of another impending movers' strike. So what if the family had to forego Mama's pickles for a few months? Wasn't the move into a newer and larger apartment more important? And Dad's new job? The painter's union had recently made him job foreman. Now the day before a new job began he would be notified by the boss and told where he would find his crew of painters. No longer responsible for setting up the equipment, he could leave home an hour later.

At this time they were just finishing up a job on a local movie theater. Just a day or two left. This had been a fairly lengthy job lasting four and a half weeks. There was not only the theater itself, which had to be closed for "renovations," but the upstairs office and marquee.

Dad hoped that the local's boss would tell him earlier where his next job would be. He told them he was moving and might be between two apartments. If he didn't get the exact address from the painting office beforehand, he would keep in touch by phone. That was no problem. Thursday the boss signed quitting papers after Dad and the owners of the theater checked everything out. Dad followed them with a wet paint brush to touch up any overlooked spots the man might notice and complain of. They were on a light crew. Half the men were moving scaffolds and supplies to their next job, "Fabrics by Zulus." Three floors of assorted bolts and pieces. Only the store, storefront, and kitchen to be painted.

Business had been good and Boris Zulusensky had let his son, Harry, talk him into letting a decorator walk into the shop. Paint was the first "must"; then some new cabinets. After a heavy resistance—"Well, maybe just fresh paint and bright interesting colors...," but a few new glass display cases for sundries, sewing notions "should be" added.

In a few days the shop was beginning to shape up or mis-shape with painting preparations. That's when old man Zulusensky began to worry. Gentle little insinuations from his customers hoping that they were not going to have to pay for this renovation. He himself knew that the best bargains usually came from places where the fabrics were piled on the floor and counters and you waded in after an inviting strip. This might look too fancy.

"Papa, it'll be all right. Don't worry, you'll see!" Harry said to his father as the painters were setting up ladders and laying drip cloths over counters and floor.

"Papa, it's really good business. Giving the place a shot in the arm will bring in more customers, and besides, it's deductible...improvements."

The old man shook his head doubtingly. "Mrs. Rensen, my first customer from way back was very upset."

"Papa, most people don't like change. Even for the better, but they get used.…"

"Harry, I don't know about price tags. I never needed them before. It's too fancy."

"You can put a price on the bolts, Papa. Look, your customers will bargain anyhow. It'll look like a bigger bargain when you come down."

"So?" He folded his arms across his chest musing. "I don't know. I'm not used to this." He struck the counter with the flat of his fist.

"Look, you can always knock off a few extra cents, like you always do for special customers. No big deal. Or you throw in a little extra yardage. You know, like always."

"You're teaching me the business now?" The old man shook his head and walked behind the bolts stacked on the counters waiting to be moved. "I don't know," he mumbled. "I don't think I should have let you talk me into this." He disappeared into the cubbyhole kitchen behind the store for his usual glass of tea.

When Dad came home that night he found two stacks of orange crates in the living room. The pickling had begun. Mama set his dinner out on the coffee table in the living

room in front of the TV while the second batch of pickles were sitting in cold water in the kitchen sink, waiting to be scrubbed. Mom and I scoured the sand off them, and our assembly line was set up to handle the pickle production. Boiled one- and two-quart jars stood on the table, counters, stove, and an emergency set-up bridge table. Every surface was commandeered for the procedure.

Michael stood with a shopping bag of dill between his feet. Breaking off just the right amount, a flower or two, he inserted the dill in each jar. Then Debbie measured and dropped the pickling spices into the jars. Jeffrey, holding a bowl of sheared garlic cloves, dropped one into each jar. I measured the un-iodized salt into the jars. Debbie followed my trail with the chili peppers.

Forty jars stood on the kitchen table. Twenty processed ones were squeezed under the cupboard next to the sink. Sitting mouth-down on a clean towel, they had dispossessed the trash can relegated to the bathtub. The washed pickles were fitted into the jars by Mama, gently, smoothly. Mama then poured warm water from the kettle into each crammed jar. Debbie capped and Michael tightened each jar lid after Jeffrey had crowned each filled jar with another little piece of dill. "One batch down, three to go." Dad watched the evening news, waiting for "I Love Lucy."

While Boris Zulusensky drank his tea, Harry went about stripping the rest of the shelves lining the store of their bolts of fabric, so the painters could paint these unencumbered. He stacked the bolts neatly on the long counter near the cash register, wondering where he could find extra room for some of these until the shelves dried. He would have to

make more room in the back. He grabbed a short stack of bolts, preparing to walk to the back with them, when he noticed his father watching him from the rear of the shop.

Eyes caught. "I made enough money—I shouldn't have let you talk me into this 'updating' *chozerei*. Alterations I needed?"

Harry set the bolts down. "Papa, if you made enough money, why did you turn me down when I wanted to borrow a little?"

"You wanted me to lend you money to throw away on a no-good—!"

"Papa! She's a nice girl!" Harry's voice rose.

"How can she be nice if she goes out with such a-a-a bum like you—who talks back to his father?"

Boris Zulusensky stalked toward the back of the store. Harry's lip quivered as he looked after his father and again prepared to move the bolts of fabric. As he watched his father disappear through the narrow kitchen door, he noticed a painter squatting on the floor on the far side of the counter scraping the underside of a shelf. Not everything had been put away yet. Guess an hourly contract was an hourly contract and the guys divided up the job.

He tucked the bolts on a narrow counter in the kitchen. Hindsight. Wished he had asked the landlord for the key to the basement. The upstairs was full to brimming and he couldn't stop the shipments in time, when he finally convinced papa to paint. The landlord might have let him use the basement. They never used much storage. All samples were pretty much out on display and replaced until they were close to running out, before reordering quickly. Pain in the neck finding space now.

Boris snorted as Harry entered the kitchen with a second batch of bolts. These he stacked on the kitchen chairs.

"Want some tea?" Boris asked without lifting his head from the newspaper.

"Thanks. I'll take some in a minute." Harry steadied a mountainous heap of bolts and pulled up the lone vacant chair to the table. "Pa, I've been looking at the sign again. What do you say we get a new one? Nothing fancy. Neat—and finished this time. What do you say?"

The old man held up one hand. "Whoa! Hold your horses! Not so fast. Let's see if the business survives this, uh, 'alteration.'"

"Papa!"

"Go drink your tea." Boris poured hot water from the kettle into a glass on the table and pushed it toward Harry. "And go watch so they don't help themselves to the goods."

During a commercial, Dad came into the kitchen to watch the pickling process.

"I see you solved the pickle problem." He pointed his chin toward the empty wooden crates jammed into one corner of the kitchen. New freshly boiled jars sat topsy-turvy on chairs, cooling.

Mama nodded her head, proudly squeezing a reluctant gherkin into the jar she held. "Yes, we did! After the movers cancelled again this morning, at the last minute, we decided there was no time to lose and since we're moving so much already, why not these, too? The week is short. The pickles are almost out. If the movers come tomorrow, let them come. If we lose some...." She held the jar toward the heaven-ceiling with a shrug. "At least we tried. I wanted to

use cardboard cartons, but Debbie, bless her heart, remembered that when we turn them over, jars leak. Cardboard would get wet and fall apart, so she and Michael went over to Moore Street Market and talked to the fruit and vegetable men there." Mama finished the jar and set it in a crate on the floor, next to a dozen finished jars. "The whole morning they collected crates. See?—if you look, Florida oranges marked. California lettuce. From everywhere."

"As long as the pickles are saved!"

"Yes, siree!" her cohorts answered.

"How was work today, Sam?" Mom asked stuffing another jar.

"All right. I had a little trouble finding the place, that's all."

"Trouble?"

"Well, they told me the name was Zulus. Actually Meyer Lefkowitz was supposed to leave me the name and address in the office. You know the way they do with every new job, after he gives an estimate. He and Tony Merino sent the crew over there and I was supposed to meet them. So I was two and a half, three hours looking for Zulus in the Brooklyn phone book. No one in the office had the address. Do you know how many Zulus there are in Brooklyn? I don't know how many phone calls Marie and me made from the office."

"You had no address? Nothing?" Mama shook her head sympathetically as she plunged into another jar.

"No. Nothing. Find Zulus! In Africa I could—maybe. Some chance. In Brooklyn, not so good. A morning I had— a whole day I lost." His exasperation spilled over. He wiped his mouth as he looked for an empty chair. Instead he leaned against the sink.

"They can't start without you?" Mama looked up from the pickles.

"Sure. Sure they can. They had the paint there with them and the ladders, but you know how it is. Three cigarettes and three cups of coffee waiting for the boss to show up."

"Two hours?"

"Why not?"

"You got there finally?" She struggled to tighten the seal of a jar.

Dad watched her tighten the lids. "You want me to go over them?"

"Sure." She relinquished her station. Dad took the kitchen towel and went over each lid.

"What time did you finally get there?"

"Oh, I got there late in the afternoon. Meyer gave me such cockeyed directions when he finally showed up, and you know how I know Brooklyn. I made the mistake of listening to him. Better with the BMT. His directions cost me another hour for nothing. I ran into traffic and excavations, don't ask." He spun the towel over each jar, drying and sealing it again. "This should do it good." He circled the room leaving no jar untouched, some twice if he thought he might have missed them.

"Everything is all right now. The boys know what to do, so they can go ahead without me now. When I was looking over the place, scraping a few spots easy to leave, I got caught in the middle of an argument...."

Mama looked puzzled as she waited for Dad to continue.

"The owner and his son. It wasn't so good. The son hired us and the father isn't so interested in having the place painted. Private stuff. I was just checking the woodwork and shelves,

to see what needed puttying while Hy was on a coffee break. I was on my back under a shelf. Got some earful. Poor kid. Not really a kid. A man of thirty-five, forty already maybe."

"Your father is a very smart man."

Harry Zulusensky looked up from the new bolts he was tagging.

"Good morning, Mrs. Gordon."

"Good noon, already. But as long as it's good, who cares what time of day it is?" She scratched her head under her knit hat. "He's a good businessman, your father is," she smiled.

"Is that so?" Harry smiled.

She nodded her head. "He knows how to keep up with the times. This is important. New times. New things. Changes. Life moves on and people have to learn not to be too settled, static—like old fabric you begin to rot and fall apart. You know what I mean? No?"

"I think so." He shelved a bolt of pink velvet on one of the newly dried shelves behind the counter.

"Beautiful goods you have," she said, pinching a piece of fabric on a low shelf.

Dad helped put the pickle jars into the crates, hoping to avoid breakage in passage. As each crate was filled, he set a piece of cardboard over its top before putting another crate on it. Three seemed to be a safe number stacked one on the other. Higher was dangerous, they could topple. At one point in the procedure he turned to Mama.

"You know, Molly, sometimes I think if I had my own business—"

"Yes?" She put a finger on her lips and listened.

"Well, time is not my own," he continued, disregarding the finger. "When you're your own boss—" He stacked the jars.

"Yes. When you're your own boss, you can go broke like the *chuchim* next door. Remember?" She pointed to the far wall. "He lost his shirt in his 'own business.' Better the paycheck at the end of the month. Let me look at that one, the one you're putting down now." She took the jar from his hand and lifted it to the light. "See what happens when you don't concentrate? See?" She turned the jar for him to inspect. "I didn't get enough pickles in."

"Pa, you don't even know the girl." Harry was putting bolts back on the shelves. He ran a finger over the shelf before setting the bolts down to make sure the paint was dry.

"What's to know?"

"You'd probably like Eunice if you got to meet her."

Boris Zulusensky turned apoplectic red and blustered, "I don't want—"

Harry hastened to change the subject. "Macy's is having a big fabric sale. Shall I check it out?"

"Modern children! Heh!"

"Lay off, Pa, will you? I'm not marrying the girl. Why carry on?"

"You're not marrying her? I'm supposed to be proud of you for that? Living in sin is better? Bum with a *bummerke*—a son I have." Boris lifted his eyes to the ceiling lights. "A bum...a son...this you gave me for my old age? Thank God, the daughter got married."

"Pa...."

"No more talking. Enough. Finish up and go to Macy's."

"Okay. Okay. But you gotta admit, Pa, the place is looking sharp. The colors help a lot...and the new cabinet...."

"Eh. Better it should have stayed in the bank."

"You can't complain, Pa. Business hasn't fallen off a bit even with the painters here. Inconvenient shlepping from the back and upstairs for old customers, but it's been good. It's all been good for your own business."

"'Own business.' When you have your 'own business' everyone is your boss. The hours are forever. Look how they couldn't leave us alone for a few days! It's good! Sure it's good. Big deal, 'own business!' Mrs. Yansky calls me at home. On Sunday her daughter is getting married. She made a mistake in measuring the veil, a few inches short. Could I open my shop for a few minutes? I'm on call. Like a surgeon. Who cares if you need a rest? On my feet eight-ten-twelve hours a day as it is. If you have a job—" he raised his forefinger, "even a concession in a department store—five-thirty they close. The customers can stand on their heads, the door is locked. Six o'clock. Finished. Home."

Harry listened and sat down on some newly arrived paper-wrapped bolts stacked two feet high waiting to be checked against invoices and shelved.

"Papa, you without the store? A needle without a tailor, a brush without a painter, yeah, you'd be like a tomato without salt or a corn beef sandwich without pickle. A disaster. What would you be?"

"I would be. I would be. That's life." Boris put both hands on his hips and stationed himself directly in front of Harry. "So who says you can't eat corn beef without pickles? If you have to, you have to. If this is the worst there is in life

for you, my son—" He nodded adamantly. "The pickles should be the least."

"Sure, Papa. But look. What are we living for if you can't have some small pleasures? A few luxuries?"

"In the camps they did without pickles."

"That's not fair, Pa. We're not talking about life and death."

"What then?"

"It's all relative. Maybe we're spoiled."

"You can say that again. You certainly are."

Boris walked the length of the store before Harry could respond, looked out of the window into the street, pivoted, and turned back.

"You hungry?"

Harry swallowed an angry retort. It would be in vain. Papa was always right, and you can't argue with the righteous.

"Yeah. A little. What time is it anyway?"

"Who knows? My watch is no good. It's late already."

Harry nodded, stood up, stretched and scratched his head.

"Say, how do we always get on these crazy subjects?" He lifted three of the bolts he had been sitting on and prepared to bring them to the back. "By the way, what makes you think you could work for someone else?"

"Why not? A job is a job."

"I can just see you punching a time clock."

"When you work for someone it's not so hard. There's the unions. One minute to five-thirty I close the register, grab my coat, a little tidying up maybe before, but like I said, the store is closed and stays closed."

Harry shrugged. "You're right. Okay. We'll sell the store. I know a real estate agent who'd love to handle the deal for us. In two months you'll be a free man. You'll work for Macy's yardgoods department. For you, with your experience, they'll fight Gimbel's. Of course, there might be a little problem. They retire employees at sixty-five. But you'll have a year or a little more. Great idea you have there! I'll phone Chuck Levine as soon as I get these bolts out of the way. I'll catch him before he runs out of the office."

"Wait. Wait! I'll have to sleep on this. After all, such decisions shouldn't be made in haste." Boris folded his hands behind his back and turned to look up at the shelves lining the walls above the counter. Browsed for a moment and then turned back to Harry stacking bolts. "How come you're talking so much? You have something on your mind?"

"Yes, Papa. I'll run the store myself."

"You? You won't be able to."

"You may be right, but you can't let this go down the drain just like that. Sure we can sell it, but it's been in the family so long…. And I do know the business. Maybe I'm not as good a salesman as you, but I think I could handle it."

"You?"

Harry nodded and trotted several more bolts to the back. Boris followed. "By yourself?"

"Why not?"

Boris raised an eyebrow. "Want to eat?"

"Sure. I'm starving. That's what I get for skipping lunch." He stacked the bolts in one corner of the kitchen.

"So stop talking and go get from the deli."

"Usual order? Corn beef? Two pickles?"

"What else? Go get already."

As Harry opened the cash register his father called from the kitchen doorway, "Wait! Let be pastrami for a change."

Harry stood next to Sam Kalish outside the shop. Sam held the completion papers in his hands for Harry to sign. They looked up at the sign over the doorway: FABRICS BY ZULUS. A long expanse of white followed the name on the one-and-a-half-by four-foot sign.

"No, the sign was never completed," Harry said. "The man ran out of paint that day, expected to finish it the next morning, and had a heart attack that night. And that was that. My father took it as an act of God...."

"We'd be happy to finish it. No trouble. Got a good sign man."

Harry shook his head. "After thirty-five years, my father would feel he was flying in the face of destiny. Challenging the Almighty, since business has always been decent. Sometimes good, sometimes slow, but enough to take care of the family, raise two kids. Send them to college. He's had it repainted a few times when the letters wore off. Never would let them finish the rest of the name. 'You don't change names if things are going all right,' he says."

Sam looked at him and smiled. "He's right. I remember when a child was very sick—from the old country—you would change its name. Give it a new name. Like a new start. Fresh luck, maybe?"

"Yeah. To thwart the evil eye. Hide the child from the demons that were making him sick. Right?"

Moving day finally came a week later with four hours' notice. We were prepared. All of us stayed home from school

that day. In minutes closets were emptied into the upright portable containers the movers provided. A two-man crew moved sofa, chairs, beds, two bureaus, two dressers, a large chifferobe, three barrels of dishes and pots and pans, and seven crates of jarred pickles.

"A regular pickle factory," Mrs. Cohen remarked as the movers passed her floor on the way down the three flights. Out one apartment building, a half-block push on dollies, and up three flights to our new apartment.

"Yes, we love our pickles," Mama said as the last crate was set down in the new kitchen. "And imagine, we could have almost lost them this season."

Half unpacked that evening we were too tired, too excited to go out to eat after all, and too anxious to try a jar of the new pickles in the new apartment. Mama had wisely packed the large frying pan on top and the smell of veal cutlets filled the apartment.

"Did you finish the job at Zulus?" she asked as we sat at the table.

Dad nodded as he chewed his crisp veal chop. "All finished. Tomorrow we begin Murray's Hofbrau on 68th Street. I got the name and number exact this time." He smiled, picked up a piece of quartered pickle from his plate and bit into it. "You know," he looked at the remnant in his fingers, "these are real good. The moving didn't hurt. And they're not even through setting yet, right?"

# A Time of Indecision

DAD DROVE OFF in the car to meet Aunt Molly's train. Jack turned back to the kitchen where Mom and Grandma were busily rolling out the dough for the strudel. As he looked in, the two women with their hands in kneading dough smiled at him from the heat of the kitchen...they looked at each other happily. Grandma wiped her forehead with the back of her hand, leaving a flour streak on her hair.

"It's enough already; see how the *ruggalach* are doing."

Jack's mother wiped her hands on a kitchen towel and opened the oven. She looked in and closed the door.

"Not yet, Mom."

She was aware that Jack lingered in the doorway watching her, and she walked over to him.

"Did you have your lesson?"

He nodded. She put an arm around him.

"Everything okay?"

He nodded again.

"Want something to eat?"

"No—I'm going out for a while."

"Go ahead."

Grandma began to roll the large flat layers of dough, sprinkling apples, nuts, and cinnamon sugar between the layers.

"The child looks pale," he overheard his grandmother say as he left the doorway.

"No, Ma, he's fine, just getting a little nervous."

He went into his room to get his jacket. Presents were lying on his bed in their opened gift boxes plopped in nests of fancy gift-wrap paper. Every day this past week the mailman had brought one or two presents for him with their meant-to-inspire messages enclosed on neat little cards. His tutor was going to pick him up later in the day for what he called a "dry run" rehearsal with the rabbi at the synagogue. His father and grandfather were to be on hand, too.

He took his jacket out of the closet and sat down on the bed holding the jacket in his hands. The books they were working on were open on his desk—the *haftorah* portion— as well as the *bar mitzvah* speech he was still trying to half memorize. Graham had helped him put it together while they worked on chanting the haftorah. Dad thought it sounded a little old for him, and they tried reworking phrases here and there, but most of the passages retained a

rather mature flavor for a thirteen-year-old. Besides, he understood all of the words. And Graham said people expect certain language in speeches that one doesn't use in ordinary speech.

He picked up the sheet with the typed speech on it and sat with it in his hand.

> Dear Parents, Rabbi, Relatives and Friends:
> There have been moments in preparing for this bar mitzvah occasion when I truly was not sure that I would reach this last stage, the stage of speaking to you this *shabbos*.

He wasn't there yet by a long shot.

> However, with God's help, and the wonderful support of many people here today, I am now able to pause from the reading of the Law, and reflect in public upon all this preparation. In particular, I want to relate to you my understanding of the meaning of bar mitzvah.

Meaning of bar mitzvah. If only it didn't mean so much to his folks. He loved them and always got along pretty well with them. Didn't seem to run into some of the things some of his friends had with their folks lately. But his bar mitzvah seemed to matter so much to them—maybe more than he did—but he knew that wasn't really so. Why did they have to make such a big fuss about it? Mom expected almost two hundred people in *shul* this Saturday morning for the bar mitzvah service. As his grandfather had explained this

service, "It's just the ordinary Saturday morning shabbos service, and you are called up to read a portion of the Torah as any man would be." This is the way of initiation into manhood; from then on he could participate in religious services as an adult man, in the minion.

> The Jewish tradition is that from the time of bar mitzvah, I am held, under Jewish Law, responsible for the fulfilling of God's commandments, and the teaching of the Torah. I begin to see that for me, the first step toward manhood is the willingness to accept responsibilities as a Jew....

Maybe it was too hard to be a Jew. Christian boys seem to have it easier—no Hebrew school, no bar mitzvah to go through.

The new little *tallis* his grandfather had ordered for him from New York lay in its box on his desk. His father would drape this around his shoulders at a certain point in the ceremony. This was the symbol of manhood; to wear the tallis, the traditional prayer shawl. The shawl that a Jew prays all his life in and is buried in, his father once explained.

He looked up toward a shelf on his bookcase. He knew there were two single dollars lying pressed against pages fifty and seventy-five in his *Birds of America*—one flat against each of these pages...and a five-dollar bill in *Tom Sawyer* (page 100). He had saved these from allowances and odd chores. Jack had planned to phone Southern Pacific Railroad to see how far the seven dollars would take him, but he had no particular destination to ask for; he would have to look at the map first. Maybe he could even get to L.A. Then he

could look up Harry Spector, one of the boys he had met in camp last summer. His folks would probably call the police to find him and bring him back. They'd probably be terribly worried and angry. But if he just skipped this Saturday he couldn't be bar mitzvah, since he had prepared the portion that was to be read this Saturday, only this Saturday morning, and not to be read again in rotation until next year.

All of his friends had been bar mitzvah. Why was he so frightened? Larry Shapiro muffed part of his haftorah reading, stumbled through the passage and recovered later. Everyone was proud of him anyhow. All his relatives and friends stood around patting his shoulders And shaking his hand. Larry couldn't even learn the sing-song chant properly, and read the Hebrew as a flat recitation, and that was all right, too.

Maybe he was afraid of sinning? After bar mitzvah, your parents could no longer absorb your sins. You had to answer for them yourself. Would he go to heaven when he died, if he skipped the bar mitzvah and hurt so many people by that act? Grandma told him all good people go to *Genaden*, even good non-Jews. The family would forgive him if he skipped out now. They'd be mad but they'd have him back. All the baking and invitations going to waste. Aunt Molly would enjoy her visit anyhow. He could leave tonight and even be back Sunday. They might think he was hurt or dead—or kidnapped. His folks would worry and maybe even cry. The only time he saw his father cry was when his father led the orphaned daughter of his boyhood friend under the canopy for her wedding. But those were tears of joy. He wished he could have discussed it, but his folks would probably laugh as his friend Kenny Z.'s folks had when Kenny offered to support his folks in their old age if they would let him skip

having a bar mitzvah, even offered to put it in writing—but they only laughed.

"It is very important for a Jew to be a Jew now," his father had told him. One did not shirk this responsibility. All the moral obligations the folks speak of. He pulled up the desk chair, got up to reach the two books on the highest shelf of the bookcase and took them down. He blew the dust off the tops of them before he opened them. The bills were just where he had put them. He took the three bills and folded them together and tucked them deep into his jacket pocket. He would call the S.P. later.

He listened as a car pulled up. Dad might be back with Aunt Molly. Dad's younger sister was coming all the way from New York...she was flying in on TWA. He glanced out the window. It was the caterers. They were bringing in some folding tables and chairs. He hadn't given any thought to the small luncheon reception they were having at home after the bar mitzvah. He couldn't think any further than the bar mitzvah itself. Mother and Dad had talked to him about having a luncheon for a few of Dad's business associates— old friends and of course, the rabbi and all who had been so helpful in preparing him for the bar mitzvah. He knew that even with his mother supplying many of the things to be served to the guests—Dad had said that her blintzes were superior to any he had eaten at any catered affair—still the cost was high. And business hadn't been that good for Dad this past year. Grandmother had offered to help pay for the reception when they were worrying over the guest list—trying to keep it small and still not overlook anyone. But Dad said they would manage by hook or crook, and they would not skimp. After all this was their only son.

Yesterday he had scooted over the fence into Kenny's backyard. The backdoor was open and Ken was having peanut butter on bread in the kitchen. The peanut butter had gleamed flat and slick under the kitchen light as he had opened the door.

"Hi, Ken."

"Have some," Ken had pushed the plate with bread toward him. Jack had taken a slice of the peanut butter coated bread.

"Ken, did you ever think of running away before your bar mitzvah?" he had asked him.

"Probably might have if I had thought of it."

"What did you think of up there?"

Ken swallowed the wad of peanut butter and bread he had in his mouth.

"Gosh, I don't remember anything but being afraid I'd pee in my pants—I was that scared—kept running to the bathroom till the last minute—you don't really want to run Jack, nah!"

"No?"

"It's not bad once you get started. You look at the book and the rabbi and forget the faces in the front. Besides, it takes more guts to run away."

"Think so?"

Ken had started to say something but peanut butter and saliva flew out of his mouth with the first word. Both boys sat and laughed.

"You'll be all right...you'll see!" Ken had yelled at him as he was leaving.

He looked at his tallis and felt the very white soft fabric. Should he try it on? He could fold it back again into its

neatly boxed folds. He remembered his mother telling him that she had seen the great Yiddish actor Jacob Ben-Ami in *God, Man, and the Devil* when she was a little girl. The man sold his soul to the devil, and when he played his violin in one scene, it was as though the strings of the violin were souls and the music that came from it was indescribably beautiful, sweet and melancholy. Mother said everyone in the audience cried from their hearts.

He draped the tallis around his neck and smoothed it over his chest as he looked into his dresser mirror. He raised his hands, crooked his head to cradle the imaginary violin held in his lifted arms. Was a thirteen-year-old soul worth much? Should the devil put up much of a fight to wrest his soul from the Almighty? When Jacob Ben-Ami died the sweet strains of the violin were heard—he returned to God and goodness. He was forgiven his transgression, his pact with the devil, and made his peace with God as he died.

He heard a car pull up and stop in the driveway. Quickly he pulled the tallis off, draped it on the bed into its original creases, flattened and folded it back into the box. He ran down the stairs. In the entryway Grandma and Mom were kissing Molly. Dad had her suitcase and she cried out to Jack as he came running down the stairs toward them.

"How's our young man? Here come give us a hug!"

He ran into her and was squeezed in a grip of fur and perfume. He looked up into his aunt's smiling eyes. She was so pretty and looked so happy to be there. After many more hugs and kisses Grandma and Mother took charge of Aunt Molly and had her in the kitchen for a glass of hot tea and family talk before she had a chance to get her hat and coat off. Dad took her things into the guest room and winkingly

pointed out to Jack one package in amongst the luggage he was carrying for Molly evidently earmarked for him.

Jack came into the kitchen too, and had cookies and tea with the others. He suddenly remembered that he still had his jacket on and took it off and hung it on the back of his chair. He sat with his cup of tea and tried to listen to the conversation. They were so comfortable together—so happy to catch up on family gossip and to just be together.

Last Saturday when Dad had taken him to the Saturday morning service in preparation for his bar mitzvah the old *shammus* had come up to them as they entered the vestibule of the synagogue. He helped Jack straighten the *yarmulke* he was putting on his head, patting it gently to Jack's head. "Yankele, you know your portion already?" he asked Jack, including his father in his look. His father shook his head.

"I hope so."

"*Oy, 'siz schwer zu sein a yid,*" he mumbled as he walked away. Lately, everyone had been telling him how hard it was to be a Jew. He couldn't figure out all that...he hadn't found it so hard...until just now. But maybe he wasn't Jewish enough. He went to services once in a while. Had been taking Hebrew since he was eight, and gone to Sunday school since six. Sometimes he couldn't quite grasp what the adults meant. Maybe it was hard to be a Jew when things happen like they did in Germany. When his folks talked about Hitler, their voices dropped and their faces looked hard and fearful. He had seen a few articles and books, but he hadn't been told much about that period. He knew it must have been awful. In speaking, Grandma would group Pharaoh, Pilsudski, and Hitler as one.

A long time ago he had overheard his folks tell the story

of the Russian Jewish doctor who had married a gentile girl, but when Petlura's men were approaching the town and he was urged to escape, which he could have as an accepted convert, he chose to stay with them and die as a Jew. What made him do that? Moral obligations? More than that.

Jack watched Grandma shovel one tray of cookies into the oven and pull out another.

"Yankele," she called to him, "here taste some of these."

She pushed a bowl of cookies on the table toward him, and then shoveled another tray of cookies into the hot oven. These were for the *Oneg Shabbat* after tonight's Friday evening service, and some for tomorrow's *kiddush* after the bar mitzvah. He finished his tea and picked up his jacket. He strolled through the warm cookie smell of the kitchen into his own room. His father was calling him from the hallway. Graham must be picking them up now. He gathered up his haftorah booklet and his speech. If only the rabbi wouldn't keep referring to him as his father's dear "little" boy in front of everyone. He hoped he wouldn't do that tomorrow. Tomorrow he would stand on the box behind the podium and, before the ark of the covenant, in his boy voice, he would declare his willingness, his eagerness to be a Jewish man.

> Blessed art Thou, O Lord our God, Ruler of the Universe, who has selected good prophets, taking delight in their words which were spoken in truth. Blessed art Thou, O Lord, who hast chosen the Torah, thy servant Moses, Thy people Israel, and the prophets of truth and righteousness.

And, please God, he would be a good man.

# Was Last Night the Party?

"WAS LAST NIGHT the party?" Mrs. Schaeffer squinted at Mildred as she walked by her down the stoop.

"The party?" Mildred halted for a moment.

"Leonard's engagement party."

"I guess so," Mildred answered. Confirmed busybody. Got to move along or I'll miss my train. Mom says never be rude to her. She's getting on. And she means well. Nice old lady sometimes. Biggest mouth in Brooklyn.

"You weren't invited?" Mrs. Schaeffer pursued.

"No. Why would I be?"

"You weren't invited?" Mrs. Schaeffer clucked her tongue. "And you used to be such good friends.

"That was in elementary school. A hundred years ago." Mildred rubbed the instep of one foot against her other calf. How to bring this conversation to an end? "Leonard went off to college, remember?"

"Yeah. Yeah." Mrs. Schaeffer was watching her, waiting to see her expression.

"There was never anything between us. We were just friends in high school."

"Just friends?"

"Just friends."

"I guess your Momma and Mrs. Turtletaub would have liked something there—maybe they expected—"

Mildred shrugged.

"What's to expect? Huh? With today's children. Go know. You think he's in love with her?"

"I should hope so. After all he is planning to marry her."

"Mrs. Haimovitz and I always thought he was in love with you."

"Hardly," Mildred smirked.

"He met this girl in college?"

"On a long weekend at a friend's house in Pough-keepsie."

"A nice looking girl?"

"I hear she's lovely."

"Her father has a lot of money I heard."

Mildred nodded and put one foot on the lower step before answering. "In stocks and bonds—real estate, too, I think."

"In high society?" Mrs. Schaeffer held.

"Some of that I'm sure." Mildred shifted her purse under her other arm. "I really must run, Mrs. Schaeffer."

"You'll catch another train in two minutes, the way the BMT runs. You'll make it. You'll make it! I never get a chance to see you, but I always ask your mother about you, every time I meet her. She's very proud of you, you know? She told me about your scholarship."

"Fellowship."

"All right—fellowship. Same thing." Mrs. Schaeffer shrugged her shoulders.

"Well, this is a teaching fellowship, not a grant of money."

"Just as big an honor."

Mildred smiled, "I don't know about that."

"It's a wonderful thing," said Mrs. Schaeffer waving a hand with emphasis. "That Leonard!" She shook her head, "For all his smartness—eh, dumb!" She looked at Mildred appraisingly. "After you, how could he even look at someone else?"

"He really didn't know me that well. We only dated a couple of times, Mrs. Schaeffer. Nothing serious."

"A couple of times is not nothing!" Mrs. Schaeffer broke in. "He's making a big mistake."

Mildred took another step down, glancing at her shoes, smart Italian heels which set off her legs. Good instep and calves.

"I really must be going." She looked back up at Mrs. Schaeffer as she finished descending the stoop.

"You liked him, no? A little?" Mrs. Schaeffer asked. "As a friend, eh? Such a nice looking boy. With his mouth he'll make the Supreme Court, but under his nose he missed the best—and so smart."

Mildred waved goodbye and turned toward the subway.

She appraised her figure reflecting in the glass storefronts as she walked. At least one of the young professors in her department looked at her with approval—warm smiling approval. And there was Mark Horowitz, another neighborhood boy who was making good. She smiled as she hurried down the stairs of the subway entrance. Mrs. Schaeffer was right. There's always another train—in two or three minutes. She wasn't going to be too late.

# The Funeral
# of Myron Teitz

WE SLIDE INTO the pews in random spurts to the
sound of Beethoven's *Missa Solemnis*, some going
right, some left. We know almost everyone and nod to those
our eyes catch.

It is funny how your mind travels on the sound of a hu-
man voice droning the expected platitudes. And why not
platitudes? Everyone else will take care of the rest.

We all knew Myron, we especially since he was in the
same business as Fred. Business? Profession, I should say.
Colleagues in law, but some practice their profession like a
business, even some physicians lately, I've heard. The fellows
were great buddies until Myron screwed up some deals. That

was at the time of his first breakdown. They got him over that. It was the suicide attempt that really did him in. He was a shell after that. That's when our relationship broke completely. Myron felt Fred was responsible or contributed to the demise of his practice by not referring clients. But Myron had never built up a large tax clientele. He had so much money of his own (his wife's really), that no one trusted him to work hard to make or save money for someone else. A vicious cycle. So that's where the rift remained between us. We'd nod to each other as friends, exchange the barest words....

I hear a few words and a rustle a few rows in front of us. Myron's mother is weeping quietly and her daughter Cynthia is calming her. Next to Cynthia is her husband John, stocky to the point of obesity; a jolly hail-and-well-met fellow. An appliance salesman for years, he did well in his line, but the family, especially Myron and Lena (it must have come from them) felt he was capable of better things. So Myron encouraged him to go to law school. Poor fellow had to borrow like crazy. Lena wasn't going to help there (after all, if he really wants it, he has to make good was her way of thinking). But four years and two babies later John passed the bar. Poor John, great in dealing with storekeepers, especially in rural areas, but the city practice Myron wanted him to share overwhelmed him. He was never comfortable with Myron's clients so he ended up doing the research for Myron's cases. A clerk-plus type of position which didn't pay much better than his appliance business, but the family had another "professional man" and that was worth a lot.

We stand to sing a hymn. Fred next to me moving his lips quietly. He hates to sing. I notice how his jowls have

rounded out into heaviness under his chin, around his neck. We are none of us getting younger and funerals for our friends are part of our social life. Fred always liked Myron, or felt sorry for him. Couldn't figure out which was which. Even Fred acknowledged that Myron eyed luscious, round-figured women longingly and enjoyed chatting with them. He was so warm and affectionate, and Lena was thin—frailly, transparently thin, like a delicate child.

I remember after one of Lena's and Myron's open houses, Fred's comment about Lena's Phi Beta Kappa key exquisite-ly framed in their bedroom, and Noel Harlen's retort, "Imagine sleeping with that. Not even as good as Portnoy's liver. A dollar bill would be more comfortable." Horace Krantz heard the remark and quipped, "Yeah, Myron must get splinters sleeping with her."

"Ho! I didn't have that in mind," Fred snapped back at the fellows. "I meant all those brains would be overwhelm-ing."

"Maybe," I shot out. "She doesn't strike me as that bril-liant. Just rich. That covers a lot you know."

"Shush! That's no way to talk about our hostess, and she did get grades at Stanford!"

"Shush, yourself. You started it."

It was the same at a party they gave for their friends once. A birthday or anniversary party. We ended up in an argu-ment, Fred defending Lena and Myron, though we didn't know either of them that well.

I remember hearing Lena embarrass Myron's mother in front of company. She just didn't like the dress Mrs. Teitz had chosen to wear on this auspicious occasion. It was a ter-rible dress. But so what? The woman was almost eighty. But

to tell her in front of everyone that her dress was from the thirties? After all, Lena was only two years ahead of the rest of us in her fashionable attire.

As Myron's law practice began to decline, he began to show great interest in one of the ranches that Lena's dad had left her. It was a sprawling farm in the San Joaquin valley. Myron would drive down to it often and stay there days on end. For a while he would take their two youngsters along, until Tommy got sent off to a prep school and Dorothy to the finishing school Lena had attended, naturally. John tried to hold things together at the office. Nice guy but a nebbish in this kind of wheeling and dealing, and the practice sagged. Myron didn't need the money, but it was devastating to his morale.

John didn't know what to do, Fred told me after he had run into him downtown and they'd had a soda together. The office was too expensive for him to maintain, even his half. There was no draw. He had his family to support.

"Tell Myron," Fred said. "Put your cards on the table."

"I did," John told him, "but Myron says it's only a temporary setback," and Lena would only stare haughtily, he implied. I knew that stare. A snake's glance was more charitable.

A beam of light transects the air near the aisle. The shaft, a pathway of light hits the red painted concrete of the floor. The dust particles flake off the beam and dance around in the cylindrical light. They don't belong. This was supposed to be solemn. Real solemn.

Nita, one of Lena's cleaning girls, had told me in the market that week that Cynthia had visited the house, ostensibly to

ask for a loan, probably for help in carrying the office expenses. It was no go. Nita said there was lots of yelling.

It was funny that it should happen at a reconciliation. Things had gotten bad between the two families and Myron (probably rather than Lena) invited all of them, children and mother and all, to their ranch. Myron loved working on the ranch. He'd drive his tractor like a bucking bronco, hell-bent for destruction, a neighbor told us later. The weather was beautiful and everyone was in the kitchen after boating like in the good old days. Myron said they ought to leave the cooking for the women and took John to the barn to show him the tractor. He asked John to drive it through the gate while he held it open, so he could demonstrate a run on it.

John sat up in the metal seat and did what Myron told him. He started the motor and released the clutch and then no one knew what happened. It happened so fast and John was in no condition to remember. The tractor must have shot forward at terrific speed (that's what Fred said) and John must have panicked and tried to brake it. It keeled over. They couldn't get Myron out from under. It didn't matter anymore then. Had to be a closed casket funeral.

That was three days ago. The family's on nembutals. Dr. Maddox sits directly behind Lena. She's taking it better than anyone else. The two children flew in for the funeral. Snake-eyed and thin just like her. John and Cynthia and Myron's mother look like hell. John just doesn't look right. Who would (could) after that? Reverend Aldridge must have finished. People are rising. We file out one row at a time. He has a lovely voice, although somehow the sound of it seduces me from the words, but he must have said the right things. He always did. We follow the dancing light out of the church.

# Tante Lena

TANTE LENA LIVED on 81st Street, only a few blocks from a small market—two stores, a grocery, and a butcher shop. For forty years she gave voice lessons and sometimes even piano on request in her little flat to boys and girls, to men and women. All ages, all sizes came to her. A member of the Royal Hungarian Opera Company, she had emigrated in the early 1930s. Her brother had already found his niche in New York City. The son of a small shopkeeper in Bucharest, he had refused to follow in his father's footsteps.

At eighteen he ran away, worked his way across the ocean in the kitchen of a luxury liner in 1928 and arrived here in time

to see U.S. prosperity sweep into the Depression. But the few months of prosperity gave him a taste of luxury that never left him. He was among the fortunate few who qualified, thanks to learning English at night school, to work for the civil service as mail carrier. His first day he invested in good, solid, strong leather walking shoes and made good on the job.

When he wrote to his sister Lena a few months later that he was employed by the government of the U.S., she was duly impressed and not too reluctant to give up a job that depended on pleasing the judges in bed rather than at auditions. Opera roles were tenuous; the few old standbys held them tenaciously and a young starlet had too many rungs to climb, and too many beds to climb in and out of, before she could reach the top. Security was unheard of. Any whim of any bigwig could remove her from the roster at any time.

Lena chose security in a minor role, and when she arrived in New York and realized that Mihail had a steady but not too influential position, she hung out her shingle on the basis of the fourteen roles she knew, the stars she had understudied, and her regal shapely shoulders under a wreath of golden braids. Her voice was strong, flexible, and sweet; but opera stars were a dime a dozen sitting on the pavement outside the Met waiting for some underling who "promised to arrange an audition."

Radio had already begun, but only for a very fortunate few singers, most of whom had already established names.

Her only lover—and briefly—was a handsome iceman. He held out marriage until she discovered he already had a wife and two babies on Long Island. For a weekly lesson Tony delivered ice three times a week. He had a nice tenor. They worked on duets.

48

Lena was everyone's aunt. The young girls with squeaky sopranos confided their budding love affairs to her. Young men sought her advice on how to approach their sweethearts—what kind of flowers or candy was appropriate. Youngsters discussed their school problems with her, or later the selection of colleges as they moved up in school and years.

Her life was full and busy, but not exciting until she met Jon. He swept into her living room with Mihail one evening. A friend from the old country. He sang with her old folk songs and songs from the operettas of the Hungarian stage. Swept her off her feet with his charm and wit. He left no wife and children but he had a singular ability to lose jobs. The average job lasted him four weeks. One after another, his experience wide and varied. Each Sunday he plunged into the want ads, x-ed the interesting ones, checked those he had already exhausted. Lena would fix coffee and kuchen for Mihail and Jon after the dinner meal, usually served in the dining room on Sundays.

Tonight was a very particular night. It was wet and cold out. An unexpected incipient shower had turned into a storm over New York—the sweep of a sudden change marking the end of fall.

Mihail invited himself to spend the night in his sister's apartment as he watched the rain from the window. The heavy drops flowed into rivulets running off the sidewalks, running down to the sewer gratings at each corner. Heavier, harder came the rain; the wind beat itself noisily against the glass panes of the windows.

"Of course, you may spend the night, Mihail, but Jon—?" she opened her palms.

49

"Oh, I'll take the couch. If you have some extra bedding we can set Jon up on chairs. If you have—"

"I think I do," she smiled and ran to the hall closet. Old sheets, an old quilt. They could cover themselves with coats if they had to. She had her old wool coat and a fur coat of several seasons.

"We'll do with anything you have," said Mihail.

In twenty minutes the couch was set up and three chairs assembled for Jon. They laughed and talked, drinking hot wine that Mihail helped Lena fix until almost midnight and broke off finally in deference to Mihail's early hours as mailman and Lena's students who would be coming in later in the day.

They turned in. The toilet's last flush echoed, gurgled and stopped. The steam heat was coming up; slowly it eased and worked its way up to the fourth floor. The night noises settled down.

Lena dozed off comfortably warm and happy when suddenly she awakened. She didn't want to wake anyone, but she felt someone in the room in the darkness.

"Mihail, is that you? Make the light if you have to go to the toilet…. Mihail?"

"It's me, Lena—Jon. Sh…I only want to talk to you for a minute."

"At this hour, Jon? In the dark? Is something wrong?"

She felt an arm on hers as he sat on her bed. The springs creaked with his weight.

Before she could ask further, she felt his arms holding her and his lips finding hers. She tried to push him away.

"Jon, what are you doing?"

"My sweet beautiful Lena. I'm doing what I've wanted to

do since the moment I saw you—how I wanted to hold you, to touch you, your beautiful body, your hair—to kiss you, to worship you!" He breathed in heavy whispers and felt for her breasts under her nightie. He smoothed them, kissed them and lay her head back on the pillow. He ran his hands and lips over her body. She shuddered and held him, returning his hot wet kisses. He lay on her and twitched between her legs. Kissing her goodnight he slipped out and went to his chair-bed. She lay there ecstatic and frightened until dawn and then slept.

Jon offered to marry her when she told him she was pregnant. He had offered her marriage before, but he was still unemployed and futureless in practical terms. She turned him aside.

"First settle yourself," she would say. "When you have a job and can afford a wife, we'll talk."

She told Mihail. He threatened to kill Jon, and Lena asked what good would that do? What would it solve? She couldn't afford to give up her lessons, but she knew she would lose her students as her pregnancy progressed. In her third month she decided there was no out and married the father of her unborn child. He moved in and slept with her in the big double bed in her tiny bedroom. He lay there and read during the day while she gave lessons. Occasionally he went out. Once in a while he even returned with a job that would last a scarce week. Proudly he would bring her a check, and she would put it in the teapot in the cupboard— a favorite teapot of Czech china.

The baby came early and Lena was slow in recovering. Jon was to take care of the baby while she gave lessons. Fortunately

the baby was good, slept well, and woke only for feeding. When Jon called, she would dash into the bedroom, where little Jon was squirming in his father's arms. She would seize him, feed him and return him to Jon to change and put back to bed as she rushed back to her student. It worked for a while, but then Jon began to chafe. He liked the freedom of walking the city streets looking for a job, meeting others in his position, chatting over long cups of coffee.

The baby broke into Lena's lessons, try to group them as she would. In between lessons she cooked and cleaned. The house smelled of cabbage and milk bottles as she tried to wean the baby, giving it to a neighbor for a two- or three-hour interval daily for a small sum and a weekly lesson for her teenage daughter.

In the spring the neighbor moved. Little Jon was walking. Lena kept the playpen in the living room near the piano, so baby Jon could feel secure. Occasionally he broke into a lesson and cried until Lena held him, and hold him she would on one knee, playing vocalizes with the other hand. If he disrupted a lesson, she added time not to shortchange her student.

One day when little Jon was almost two, Jon came to Lena with the thought that he would be better off in the old country. There he belonged, he felt, and there he could earn a living. Lena and Mihail tried to dissuade him. There was so much unemployment in Europe. Besides, his wife and baby were here—no one was throwing him out of the house. But Jon was adamant. He would pine away and die here. Perish of frustration. He lay in bed two weeks sulking until Mihail with Lena's little savings booked him passage on a freight steamer for Rumania.

A week later he kissed his wife and baby goodbye at the wharf. Promised to write and send money weekly. If things developed as he expected them to in a year he would be sending them their passage money to join him.

Mihail shook his hand and promised to look after his sister and nephew and Jon sailed off.

Ten years went by and little Jon wrote weekly letters to his father. The return mail rare and poorly written spoke of seeing him soon—always soon. Little Jon entered high school and hoped to go to college. He planned to go to one of the city colleges. Entered CCNY, studied hard and made his mother proud. His uncle stood by encouraging.

One day he came home to tell his mother that he had enlisted. It was the least he could do for a country that had given him so much. Lena cried. Mihail said he should have waited a little longer, but what was done was done.

The boat he was being shipped over to Europe in was torpedoed, and little Jon was brought home blind. Mihail took him for Braille lessons three times a week privately until he was able to make his way to the government-sponsored classes run by the city.

Jon learned how to make baskets and the government helped him. With the small G.I. compensation he began school again and found a part-time job in a settlement house, teaching youngsters the raffia basket crafts.

Lena felt that things had settled down for both of them again. Her life revolved around her students, a busy schedule of lessons and little group concerts for parents and relatives, at which she served tea and kuchen.

On one warm sunny day she returned from the market and found a crowd clustered around the stoop at the bottom

of her stone tenement steps. Tear-faced Mrs. Moretti, who lived next door, led her into her own apartment, sat Lena down and told her that she had smelled gas, knocked at Lena's apartment, and getting no answer called the super to unlock the door. They found young Jon on the floor in front of the oven. The ambulance phoned had tried resuscitation. Mrs. Moretti wrung her hands and cried. She made Lena spend the night with her. The morticians were called to take the body.

Lena could not look at the piano for many months. Months passed before she opened it to dust the keys.

One day as she sat at the window looking out into nowhere, one of her younger students knocked and brought her a small bunch of spring flowers. Lena wept over the flowers. She fixed the child and herself some tea and afterwards asked the little girl if she could still play the duet they had been working on. The young blonde head nodded vigorously, wiping the cookie crumbs from her mouth. Lena opened the piano. They sat on the bench and played. Before the little girl left they had scheduled another lesson and Lena dusted the piano thoroughly, opened the window, picked up her student appointment book and went to the telephone.

# Frimme Gittel's Encounter

FRIMME GITTEL TOOK to her bed one day. It would only be a short rest, to lie for a few minutes to gather her strength. Grouping her thoughts she lay a listless figure, heavy with cares and chores to be done. Her mind was filled with the images of the job ahead, but her body would not lift itself from the pillow. All she could do was open her heavy lids to look around her at the small room—the square boxed-in ceiling, clean but in bad need of another coat of paint. There were bare areas on the ceiling where the paint had dripped, dried, and fallen into slivers to be swept up with the dust of the floor.

Morris came in after work and found her lying on the bed.

"Are you sick?"

She could barely nod. Weakly she opened her mouth.

"Just very tired," she said. "I'll be all right after a good night's sleep."

Lisa, her oldest daughter, twelve, took her mother's shoes off and helped her undress. She began to shiver as she was put between the sheets, the covers drawn up under her chin.

"I'll fix my own breakfast," Morris called when he saw Frimme attempting to rise the next morning. She was too dizzy and couldn't sit up. Lisa brought her some tea which she took, sipping slowly, breathing with difficulty.

"Mama, shall I go for the doctor?" Lisa asked, looking at the trembling, sweating body of her mother. Her nightgown clung to her with fevered perspiration.

"No, we must be practical, dear, I think it's only a chill, a bad cold. With a few days' rest I'll be back on my feet." She patted the girl's thick childish hand holding the soup bowl, the other hand spooning out sips to her mother's lips. "Look, you're making a baby of me," her mother laughed.

The day wore on. Night covered the city. Winter coolness had set in. Frimme insisted that she take the room at the farthest side of the house, so the others wouldn't catch whatever she had.

Mrs. Horowitz, the neighbor, was sent to bring the doctor. Morris had to catch the early bus to the factory; some extra piece work had come in, so he insisted that someone be found to stay with Frimme Gittel. Lisa stayed home from school again and sat near her mother. She would reach and touch her hand periodically as she slept.

The doctor felt it was pneumonia. Hospitalization was advisable.

"No, I will not hear of that," Frimme said. "We have no money for that—or for much else. I can get better right here at home. See what a good nurse I have!"

Morris looked in on his wife when he returned home in the evening.

"Are you feeling better?" He was going to turn down the hall toward his room when he called back to her again through the door, "Shall I sit with you a while?"

"No. Remember what the doctor said—it might be contagious and we need you more at work. Mrs. Horowitz has been looking in on me. I wish Lisa would go back to school. She's missing too many days because of me."

"Mama, cut that out. I'll catch up with school work. That's no problem."

"Such a good girl—sweet child. She even made the chicken tonight following my directions, like a little lady, a real *balaboosta* when it comes to the house."

Tuesday the doctor came. He questioned the advisability of keeping Frimme at home. Frimme protested again; her care could not be better anywhere else.

One night as the fever raged in her body, Frimme thought she saw a shadow in her room. She cried out to it and it fled. The next night it appeared again, a nodding shadow near the door. She could barely make out the eyes. The mouth was smiling, but she couldn't grasp the words it spoke.

As the night wore on the shadow became more distinct and, waking from a light doze, she heard it addressing her.

"Frimme, are you ready to come with me?"

"Who are you?" she asked, her fright buffered by her fever and dizziness. She was not afraid of the figure as she

might have been if she had full command of her faculties. This was unreal, as fever dreams often are.

"You know who I am, Frimme Gittel—you rarely use my name in vain."

"I use your name?"

"Yes, when you spit three times."

"When I am avoiding evil?"

"You call it that."

Frimme remembered that as a girl she had been vain. When her mother caught her looking at the mirror too long she would seize her head and spit behind her ear, into the air. "Tu! tu! tu! Let not the Devil see or he will mar your beauty and take the loveliness away." Jealous spirits hover everywhere. Suddenly she was aware of his eyes watching her. Her thoughts had carried her away.

"What do you want with me?" she asked.

"I would like to make you a wager."

"A wager? What kind of wager with me?"

"Just a friendly wager."

"For what reason?"

"You've been a good woman all your life and I want to do you a favor."

"A favor? For me? What kind of favor?"

"I want to see your family well-provided for when you are gone. You would like that, no?"

"Of course, but that is in the hands of the Almighty."

"The guy upstairs sometimes gets very busy and doesn't quite get around to everyone."

"He will provide as He sees fit—that I am sure of."

"Wouldn't you like a little extra insurance?"

"I don't think we need it."

"This won't cost you a penny."

"Nothing is given for nothing."

"Such unbecoming distrust from a pious woman. I will take the responsibility—the wager will be totally on my side."

"Why?" Frimme felt her body getting hot again, and moist areas of her flesh stuck to the sheets.

"Why? Because I like you and admire you as a person. Isn't that reason enough?"

Frimme smiled. "Some person to admire! So what is your wager?"

"I believe that somewhere in your subconscious there are evil thoughts that you have suppressed."

"Perhaps. It is hard for someone to think only good of everyone, always. I can't deny that possibility." Frimme Gittel looked at him with her sick eyes. "Is this a fair time to discuss this when I'm at such a disadvantage?"

"Disadvantage?"

"My head is buzzing, the room keeps going around in circles, and you want me to discuss such dialects."

"I have no intention of taxing your intellectual capabilities. I'm only asking you to remember some simple facts."

"Simple facts? What's so simple? You want me to remember nasty thoughts I had about people, that's simple?"

"You don't have to remember details." The shadow swished his tail and sat down on the only chair in the bedroom, one of the kitchen chairs.

"You don't mind if I sit, do you?"

"It's all right. Be my guest."

Her pillow was beginning to feel hot under her neck and

she tried to shift her head to a cooler spot on the pillowslip. He cocked his head at her. "You're getting uncomfortable?"

"No, not really. It's been like this for a few days." She turned her head to the wall for a few seconds, trying to escape his glance. Her eyes carried the image of the yellow slanted glittering eyes to the wall. "I'm sure when the fever goes, he'll go too," she said half to herself.

"What's that?" he said, squirming on his seat. "You don't think I'm for real? Huh! There's an unbeliever for you. Maybe she thinks I'll disappear when the cock crows!"

She had turned when she heard his mumblings. "I don't know about your disappearing when the cock crows in the morning. I don't know whether we can accommodate you that way. But maybe you're what the kids call a figment of the imagination—my conscience, something I ate, or just part of my illness."

"I'm not!" He jumped up, his eyes flashing, his tail swishing and twisting. He bent closer to her and she could feel his flaming hot breath and see his horns. "I'm for real!"

"So you are, I see now," she sighed. "I'm very tired and I really need a rest to get some strength back so I can discuss things intelligently, or as intelligently as possible, to do the subject justice."

"Aren't you afraid of me?" He leaped up on the chair and sat on it with his bare feet under his knees and haunches, his hands waving freely.

"I guess so," Frimme Gittel answered. "I guess I should be. Maybe I'd even be more frightened if I weren't so sick. You know you're very hard for me to believe in, really."

"How is that? Everyone believes in me. You've used my name, as I told you, even called upon me."

"I must be delirious. Maybe we spoke about you, but to call on you…!"

"Sure you did! Remember when the cat climbed on the table and you caught it licking the naked chicken? You told her 'Mozel, the devil take you'!"

"So I did. She was a good cat. You didn't take her. That was a long time ago. She died only a few months ago."

"Yes, when her nine lives ran out. But we're digressing. What I wanted to point out, to prove, is that I am in your thoughts and on your tongue more than you realize."

"Because I cursed the cat two years ago?"

"No, not only that." He got up from the chair and moved it closer to her bed. "A few weeks ago you said something similar to your husband."

"I told him to 'go to the Devil' you should excuse the expression, please," she said contritely.

"Not exactly."

"No?"

"You rather implied that he was going or coming my way."

"How was that?"

"Remember the trouble he was having with his business partners?"

"When Yussi took the money out of the bank and invested it without telling him a thing."

The devil nodded hard in the affirmative. "Exactly."

"I'm sorry I can't remember what I said."

"You said your husband would be burying his business and going straight to hell if he let his partner dance on his head like that."

She sighed weakly. "I might have said that."

"You also said his partner 'should only burn in hell for such shenanigans.'"

"Could be I spoke like that. I was so upset." She tried to sit up. "Can you blame me? Look at this grand apartment. Straining all these years to save a few cents and he spends it all on a big nothing idea! For this we worked for years. Remember—uh, Sir, Mr. Devil, my husband began with a pushcart on Orchard Street. He's no young man anymore. We still have one youngster at home. It's not easy to have this happen and sit still and not at least say something. The heavens themselves cry at such injustice!"

"You don't have to go that far to emphasize your point."

"Excuse me."

"But you did harbor ill will toward the partner."

"Ill will? What are you supposed to feel when someone steals money you have slaved to save—for the children—for our old age—just a little bit? How much do you think we need or ever wanted? Fancy clothes I never had. A hot water flat with decent steam heat is all I asked for. You've got no big spender here."

"I know you've been frugal, Frimme Gittel, but surely you must have been resentful when you saw your friends in furs and diamonds."

"Resentful? Why, Malke has a big diamond but what *mozel* besides, with her husband weighing three hundred pounds? Her son is a nebbish they can't put through college. Who in his right mind would envy her? No, Mr. Devil, I have been lucky, lucky in my marriage, my children. Knock wood."

She moved one hand to tap on the side slat of the bed under the mattress.

"But you must have hated Malke when she flashed that rock in front of your face—you must have wished her ill," he grinned.

"I look at the ring, its beautiful facets and sparkles. I also see whom she shares her bed with. Keep the diamond, I can't begrudge it. Such diamonds couldn't pay me for one night. I'm sorry."

"But in the split second before your mind rationalized her position, you must have hated her and wished her ill."

"You're still out to prove that?"

"Sure, it's part of the human makeup."

"What's human makeup?"

"To envy, to hate."

"And the other side of the coin."

"You mean love and self-sacrifice?"

She lifted her head slightly to nod.

"Naah! That's a lot of baloney! People only give when it comes back to them."

"What is your wager that requires no investment from me?"

"That you are capable of evil thoughts that you are not aware of."

"And what is the bargain that is forfeit if you prove it so?"

"I'll take you with me."

"Why am I so challenging?"

"Well, if you must know, you're earmarked for other things, but I think there's a flaw in all humans."

"And if I prove you're wrong?"

"Then you stay."

"And if you win?"

"You'll come with me."

"And then what have I got to gain?"

"What do you mean to gain? What have you got on your mind?"

"Well, to be honest, can you make it worth my while to lose the wager?"

"Life itself is not enough?"

"Maybe not."

"You're bargaining with me?"

"You came to me first, remember!"

"True. What do you have in mind?"

"I'll go with you, but I would like to leave the family taken care of."

"Sorry, I can't accept you that way. That's self-sacrifice, so that balances the book in your favor."

"You mean, I can't work something out with you?" She half raised herself from her pillow.

"No, not on that basis. It has to be for your benefit, not for others."

"But it will be. I'll be buying peace of mind."

"It won't work, Frimme Gittel."

"Too bad. Oh, it would have solved so many things."

He got off the chair, stood behind it and put one foot on the lower rung. He stood there for a few minutes, looking at her.

"I'd better go." He was slinking out the doorway when she called, "Maybe you'll come back with another proposition?"

He shook his head, "I doubt it. This takes more strength than I have. Be well, Frimme Gittel."

She nodded goodbye and fell asleep.

# Medicine

MICKEY TIED THE NOOSE around his neck, checked the chair under his feet, then jumped, kicking it over. All he felt was a tightness around his neck and an inability to breathe deeply. He was suspended in space. There was no time, no place. Shortly he felt nothing, not even his body swinging gently. Blackness. Total blackness that suddenly began to lift and gray. He was standing on his feet again, looking at a shapeless gray cavern. He rubbed his eyes; the blurriness was solid around him, but light. He felt light. Not disembodied or floating, but the heavy lump inside him was gone. He looked at the cavern wondering whether to walk toward it. Everything about him was murky gray, fog-like.

Suddenly a figure appeared in front of the cave. He wondered if it had been there all the time. A figure with a turban. As he looked the figure beckoned him on. He walked toward the man, whose features began to shape as he walked closer. Clear handsome features, a full beard on his chest. The man watched him as he approached with bright, friendly eyes and smile. The man was tall, no, not so tall as he came close to him, actually his height, but dignified and the robes made him seem larger.

Mickey stood next to him, wondering what to say, when the man spoke.

"Don't be frightened. I've been expecting you for a while."

"Me?" The man nodded. "Why?"

"You were assigned to me because of your interest in medicine."

"I'm afraid that's over."

"Would you like to talk about that a little?"

"There's not much to talk about." Mickey shrugged, despondently angry.

Without paying much attention he followed the man into the cavern and into a room. A lovely room with satin hangings and beautiful Persian rugs.

"Sit," the man said, waving him to an exotically shaped upholstered chair, "and we'll have some coffee and talk."

"That sounds good." Nice old gent. No reason to be angry with him because he didn't get into med school.

A young woman brought a tray in and left. The man poured two brass cups full of coffee and offered Mickey one. He sipped the hot, tasty beverage slowly.

"You don't know who I am?" the man asked.

Mickey shook his head, "Should I?"

"I practiced medicine a good while ago. Got pretty well known for some of my publications—"

"In international journals?"

The man nodded. "Right."

"What's your name? Perhaps I've read some. What was your specialty?"

"People. I'm Moses Maimonides, sometimes called the Rambam."

"But that was centuries ago. My grandfather talked about you."

"Centuries ago? What is time? It wasn't so long ago."

"I thought you were an Arab." Mickey pointed to his turban and robe.

"Some of my best friends are. Perhaps you heard of Avicenna and Averroes? I wore these, this outfit, when I served the Sultan after I fled Toledo." He held up his hand. "That's all right, I don't expect you to be up on history too."

"Am I dead?" Mickey asked, his voice rising hysterically. "Don't be afraid to tell me, I can take it. After all I did it to myself."

"You were very upset."

"I had reason to be. Fifty rejections! And me a 4.0 student from Stanford. It's those lousy quotas, you know."

"Oh?"

"Yeah. Sixteen to twenty-five percent of the slots in medical schools are assigned to minority groups—we don't rate as that anymore, not when it really matters, we don't." Mickey felt tears rising to his eyes. The man turned his head away to ease his embarrassment. "And then my girl—"

"That, too."

"She wanted to be Mrs. Dr. Somebody and when I didn't get in, she went to look for another Somebody."

"She wanted to marry a doctor, eh? The man didn't matter, only the profession. Tsk. Tsk. It's an old story. I had some little troubles like that myself, even with a matchmaker, like the custom was then—but that's a long story. Come with me. Oh, finish your coffee first. No hurry here."

"Am I being taken somewhere for judgment?"

Moses Maimonides stood up, waiting for him to finish his coffee. "No. I want to show you a little about medicine here. It'll give us a chance to talk a little too."

"You lived in the thirteenth century, eh?"

"Right."

"They sure didn't know much then."

Moses looked at him as he walked Mickey out of the room.

"I didn't mean it that way. I mean compared to what we know now. You know, scientific technology. Maybe you don't know about that."

"I do. You see we never stop learning; those of us who are interested, keep abreast."

"I should ask how."

"There are ways."

"Then you must know a great deal. The past and the present."

Moses raised his eyebrows. "Man never stops learning— as long as he wants to."

They walked through a narrow street filled with shadowy people enrobed in fog—a gray heavy mist that clouded his eyes. He followed the maroon and gold brocaded robe into a large stone building. Moses beckoned him on through

several large halls, oddly shaped rooms hung with tapestries, into a balcony overlooking an amphitheater. A figure was carried in on a table by four attendants, followed by Moses Maimonides. Mickey blinked, looked down, and looked at Moses next to him. Moses saw his bewilderment.

"It's not that strange. Like sleight of hand, a matter of understanding principle. It deals with time and that sort of thing. There is a wise man in San Francisco State who says—and perhaps he isn't the first to have said this—that there is no present, only the past and the future. Does that make sense?"

Mickey shook his head. "Not quite."

"Well, take speaking, the moment a word is out of your mouth, it is in the past. What you say next is future until it is said."

"I see." But Mickey was still nonplussed. It made sense on some level, but knocked the hell out of the present, obliterated it totally. What a concept.

Their eyes turned back to the figures in the amphitheater. A half-clothed dark turbaned giant of a man stood on one side holding a scimitar at his side.

Moses pointed. "See him? If I make an error, hurt, injure or kill the sultan whom I must cure, that scimitar takes my head." Mickey gasped. "You think it was easy to practice medicine then? By the skin of our teeth. Doctors didn't have it so good always. In time of plague, if they didn't catch it, some were accused of witchcraft and burned. We had our share of charlatans and quacks like you do now, but an honest man had trouble making a living, believe me." Mickey's eyes were glued on the scimitar.

"Some exam to flunk, huh?" Moses chuckled, "and you do yourself in."

"But at least you got to practice medicine."

"True. And I didn't have MCATs to worry about, very true. Tell me, Mickey, what is your prime reason for wanting medicine? To please the lady who threw you over? Eh? You're not answering. Good. Think about it a little."

Suddenly the balcony became very warm. A huge metal brazier appeared, with burning hot coals. A man with his arms chained behind him was brought into the amphitheater. The sultan's litter was removed. A woman dressed in Queen Elizabeth clothes entered, followed by a man and two armed guards. They were arguing. Their lips were moving, but no sound came up to the balcony.

"Who are they?" Mickey asked.

"You don't recognize the lady?"

"Queen Elizabeth?"

"Right, and the handsome fellow with her is Essex."

"And the other man? My God, they're going to torture him."

One of the guards was ripping the man's shirt off. The other brought a heated fire-red branding iron close to the man's face. They could see the man's look of terror frozen on his face, his mouth open, screaming sounds they couldn't hear. The iron tore into his flesh. Mickey yelled. They couldn't hear. He turned his face away. "I can't watch. Can't we stop it or do something?" He ran into the hall leading off the balcony. Moses followed him. "We can't do anything. No. It was in the past. That can't be altered, but we can learn from it."

"What can you learn from such butchers?" Mickey sobbed.

"We can learn how to be kind to each other."

"A fat lot of good that does."

Moses smiled and put an arm around his shoulder.

"Who was he? The fellow they tortured."

"Lopez. A Jewish doctor who came with the Spanish Armada. Phillip's physician. Elizabeth appropriated him as her private physician until Essex jealously accused him of plotting to poison the queen."

"She believed it?"

"She loved Essex, probably believed anything he told her, and under torture one confesses to anything that is requested."

"Why did you want me to see this?" Mickey asked wiping away the tears that slipped out of the corners of his eyes.

"Let us say this is an aspect of medicine you wouldn't have dreamed of."

"Well, I've read something of medieval medicine. The doctors walking around with masks, when they thought disease was transmitted by air."

"True. But the barbaric garb they put on to fight it."

"They had nothing else. Doctors only became big shots in the last fifty years with the introduction of the wonder-drugs. All civilization will count itself before and after penicillin."

Mickey found himself out in the gray streets again following Moses. Suddenly it began to rain and they ran into a tavern for shelter. They took an empty table on one side of the room. Though they had been rained on, Mickey noticed their garments were dry. Several people were sitting in small groups at a few of the tables. A man stood behind the bar filling pewter mugs with liquid from the barrels behind him and set them on a heavy table. A young voluptuous waitress set several

on a tray and sweepingly distributed them to the tables. The hands reaching for the mugs clamped on her breasts, pinching and letting go when she smilingly slapped them.

"Take numbers gentlemen—there's a long evening ahead."

She saw Moses and Mickey and made her way to them. She was beautiful. Mickey couldn't take his eyes off her. Her bosom bounced under her loose cotton blouse and curved up toward her throat in the deepest most beautiful cleavage he had seen outside of Harrah's. Her dark eyes penetrated his mind and he was embarrassed at what she would find there. Those dark Gypsy eyes knew what he wanted or needed. She moved with slinking earthy grace. Mickey was entranced. Embarrassed at staring at her breasts he looked down. Her bare feet were caked with mud. Beautiful feet, but such casual cleanliness. He heard Moses order wine for both of them. She turned toward the bar.

"Am I dead?" he asked Moses pointedly. "Don't be afraid to tell me."

"Does it matter?"

"Why sure it does."

"Why?"

"Why? That's a dumb question." Mickey was beginning to feel rage and some fear. "A person should know which world he's in. Look, I appreciate your tour, but what am I supposed to learn from all this?"

"You're wrong. It's what I'm supposed to learn...I am the one who is learning." Mickey was baffled. "I want to know why you should try to take your life. What makes an able young man take his own life? A man with all the world before him."

"Look, you practiced medicine. You enjoyed it, right? Huh? My rejections mean that I can't ever be a doctor. Don't you see?"

"I understand that. Why do you want to be a doctor so much that living is no longer worth it?"

The girl returned with the wine and two mugs. She poured it for them and sat down on a stool facing them. Mickey stared at her, her blatant invitation to him oozed from her eyes and chest. He could feel his heat rising. God, if only he could be with her for a while. He found Moses' eyes on him. Moses nodded as though he could read his thoughts.

"You can go with her. For a while I thought you might ask Faust for Helen of Troy, but…." He waved his hand. "This will do just as well. I'll wait here." He took a book from a deep pocket of his robe and opened it. Mickey stood. The girl took his hand and led him up the stairs to a bedroom at the end of the hall. If I'm dead, Mickey thought, this certainly isn't that bad. He followed her through a door.

When he woke she was gone and he ambled down the stairs. Moses was still deep in his book. He looked up as Mickey approached the table.

"Feel better?"

Mickey smiled.

"Good. I didn't want emotions to interfere with dialectic. You still haven't answered my question in regard to medicine."

"You really want to know why I want to be a doctor?"

"Yes, I really do. Sometimes thinking this out clarifies issues."

"That's a good psychological line."

"I've handled that, too. Some of it's in my *Guide to the Perplexed*, not a bad piece of work. Part of medicine, too, right?"

"I guess so. But the question is so odd."

"Not really. You had to write a whole essay on it when you made your applications to the medical schools. So you had to think that over."

"I said I wanted to serve humanity and all that kind of bull."

"If it was bull, then you shouldn't be a doctor."

"Well, I meant it. It was a hard essay to write."

"It must have been." Moses was frowning at him with pursed lips.

"You're disgusted with me, huh? Just like I am with myself."

"No. I'm only trying to penetrate the motive. Perhaps then I can understand the suicide. To me, to my way of thinking, except in cases of extreme unbearable physical pain, though God knows it can be mental, too, suicide is a cop-out. Hold on, don't get angry. But it's usually an inability and an unwillingness to handle oneself."

"You're going to give me a character routine?"

"It is harder to go on living at times than to close it off, you know."

"Well, what kind of answer do you expect?"

"The truth."

"I'm telling you that."

"Then that's fine. If you sincerely want to help people, medicine isn't the only means to achieve that. There are so many way to help people."

Mickey fingered the wine mug as Moses spoke. He was

thinking of his words. They were true. Why hadn't he thought more. But the pain had been so unbearable, so sharp and the shame—tears of frustration filled his eyes.

"I wanted it so badly," he blurted out.

"Of course you did, but how many human beings get everything they want? Half the world is still underfed, cold, homeless. Those who work from dawn to dusk just eeking a living, just to eat, have no time for grandiose dreams."

"But medicine wasn't just a dream for me—it could have been a reality. One acceptance was all I needed."

"Without it, it becomes a dream. We must be practical. Did you want it so much for yourself or your image; the one you didn't fulfill for your lady friend? If she hadn't left you, would you have hung yourself? If she had thought the man of greater value than the doctor that might have been?"

"I don't know."

"If you truly want to serve humanity and have a great love for people, are you aware of the number of professions that enable you to do that—teachers, social workers, psychologists, pharmacists, accountants, janitors, carpenters, plumbers, lawyers—they all serve humanity. Come." He rose. "Let's finish our tour. You know a man has to be a father, brother, son, husband—a life has many facets of service. We all have many roles to fill. And dreams, dreams are most important to man. He is nothing without them, but we cannot live in our dreams; we face reality daily in so many ways. Our bodily functions and mundane needs keep us grounded, probably for good, else the head could soar too high and be lost in a world of fantasy. Where does one begin? And the other end—who knows at times? Both are

important to the human entity. Examine these matters. You are of greater worth than you realize, as a human being. The answers are within you. Give them a little time, and you'll find them."

"Are you going to tell me that I've been dreaming?"

"Not necessarily."

"The girl was certainly real. What a—, ooh, well."

Moses smiled. "If you thought she was real, she was."

"You mean I gave her life, reality because I wanted to."

"It could be something like that." Moses extended his hand and took Mickey's and walked him out of the tavern through the gray fogged streets, through the cave. Mickey heard voices as they approached a light. Moses released his arm and smiled. He pointed to the light. "You're on your own, straight ahead."

Mickey walked on, turned back once to see Moses still standing. Moved on several yards and turned again. He was gone, but Mickey could hear his voice. "He who saves one life saves the world. Even your own," Moses added to the statement from the Talmud.

The voices became louder. The light brighter. He could hear scraping sounds.

"Here grab him. Get the rope off his neck."

"Lucky thing the door wasn't locked. God! Who knew he was that depressed? You okay, Mickey?"

"Do you think we ought to call his parents? Why don't you get the doctor?"

"He looks all right."

"You sure?"

"Yeah. His pulse is getting stronger. There's nothing they can do for him that we can't at this point—unless he needs

psychiatric help. Let's get him on his feet before we worry about that."

"Okay, Mickey?"

"Yeah, fellows. Really, I'm all right. I'm really all right now."

"Color's coming back just fine."

"Mind's okay, you think?"

"Hope so. He wasn't out very long."

"Can I have a drink?"

"You want water or the real stuff?"

"Get him some brandy. That's always used in the movies."

Mickey chuckled. "Jeff, do what the doctor tells you. Brandy."

"You don't look so bad for someone who plays games. Look, why don't you see Dr. Lazlo at Cowell? She's good to talk to. I haven't gotten accepted this year, either, I think I'll have another crack at it next year and then go for a fudd degree; anatomy, maybe—it won't be all that bad. Think about that."

"Mindy is going to Europe. Jenkins to Guadalajara."

"Fellows, I wish you wouldn't say anything about my juvenile behavior to anyone—please!"

"Sure. We understand. No more nonsense. No games. You picked a rough way. I'd have taken pills myself."

"You were thinking?"

"Sure. Everyone does one time or another. That's normal. What did it for you? Eloise?—don't tell me. Shit! That broad isn't worth all that. There isn't one that is. Besides there are plenty of fish in the sea."

"You're telling me?" Mickey sipped the brandy he was handed. "Say fellows, did you know that you just saved the world?"

# Encounter

THE OLD MAN cleared his throat and looked about him as he stood at the edge of the subway platform and spat into the shallow darkness at his feet. He was getting impatient and a little worried. There was no one else on the station. The hairs on his neck began to tingle as he thought of the many subway stories that had filtered into the newspapers these past few years.

New York was not the safe city he had come to sixty years ago. Even as recently as twenty years ago you could ride trains all night, all alone, and never have an unpleasant encounter. With police, without police near, one was still safe. He wondered if he should return through the slatted doors

and run up the stairs to daylight again. Upstairs, outside, there were lots of passersby. Not that they were always helpful when a person was attacked. He had read those stories, too. Suddenly footsteps. A dull shuffling of a pair of feet toward the turnstile. He watched. A tall black man put a coin into the slot and turned the stile. The man walked toward the platform looking at him. He carried a newspaper and sat down to read. The old man sighed with relief. If only the train would come. He tapped his toe and rocked from heel to toe watching the black man from the corner of his eye. He tugged his beard and neatened it after the wind-blown walk from Delancey Street to the subway entrance. He felt for his shirt collar, straightened it.

Suddenly he noticed the black man's eyes on him; encountered, they returned to the newspaper. The old man turned his eyes away. It was rude to stare, but he could not keep his eyes from the man. Oh, those trains. Once people kept to schedules. Once the city's transit system was the finest in the whole world. Nothing was so fine anymore. Not governments, not cities, not people. People had become like animals. Rushing for themselves. No one else mattered. Even parents and children. No one seemed to care enough. A strange fast world.

He glanced at the sitting man from the corner of his eye. Slowly he moved back from the edge of the platform and stationed himself a little further away, leaning against one of the massive I-beams. A story he had read a few days earlier entered his mind. A woman and a little dog had been attacked and killed near a subway entrance. In broad daylight, too. He looked at the man. He could well be carrying a knife. Don't they all? That's what he heard from everybody.

He gauged the distance between himself and the doors, not too far away. He could probably move fast enough if the man came at him with a knife—he could move fast, but how fast could he move without his heart giving out? Perhaps he should take a triglycerate from his pocket and put it under his tongue—just in case. His heart was beating fast already. Where was the train? And more people? He could have a heart attack and die, and no one would be around. He should watch more carefully where he was going. His heart was beginning to beat faster. He could die—over nothing. Scare himself to death? Some newspaper story: headlines in the *Daily News*: Black Man Finds White Man Dead in Subway Station, No Visible Form of Violence. Voodoo! People had strange powers. He had heard and read about such things. Every culture has them. Miracle makers, witch doctors. Hadn't he studied how the Rabbis of Safed could float their spirits out, travel and return? Sure. Sure. Some felt they were legends, fairy tales. But to some—well, you can always get someone to believe something.

Suddenly he felt the black man's eyes on him. The man stood up, folded his paper and tucked it under his arm. He stood looking at him and then took a few steps in his direction. His heart was beating faster now. He pressed his hand hard against his chest. The man was walking toward him, and called "Are you all right?"

He wanted to answer, "Sure, I'm fine," and wave the man back, but he couldn't speak. He gripped his chest tighter. The black man stood a few feet from him, staring frozen. Finally he swallowed, nodded, and waved him back with one hand. He tried to tell him that he was fine, but the words gurgled in his throat.

"You want me to call somebody? the black man shouted.

He shook his head no. He was trying to catch his breath. With one hand he groped in his jacket pocket, but the pain in his chest immobilized him. His fingers fumbled clutching the little plastic bottle in his pocket. He closed his eyes, trying to concentrate on keeping calm. Taking deep breaths he extracted the bottle. He held it in his fingers, but he could not raise it. The pain radiated through his chest. He stood for a long time, and then his legs began to buckle. He felt himself swaying, tilting back and forth as in prayer. That's what he should do—pray. Perhaps his fingers would get the strength to lift the bottle. If only he could pull it up to his mouth, he could bite the cap off. He gasped. The pain was squeezing his breath out.

Suddenly he felt a hand on his. Fingers tugged the bottle from his hand. He opened his eyes. The black man was opening the bottle. With great effort he opened his mouth to show him where to put the pill. He saw the man extract the pill and put it into his mouth. He saw the large black face near his. Dots of sweat on his forehead. He felt himself loose and faint. Grayness swirled around him. He felt the man holding him against him. He opened his eyes again. The dark face was near his. The dark eyes looked into his, large black eyes swirling in white. The pill was beginning to dissolve. He kept looking at the face. There were more sweat dots on the black skin. He was breathing slower now. Frightened worried eyes peered into his. The man was scared.

"You all right, mister?"

He felt like smiling. He would have laughed if he could. He blinked his eyes hard to indicate the affirmative.

The man sighed with relief. "Do you want to sit down?"

He shook his head no. Once the glycerine dissolved he could speak again without pain. A train came and went. The man stayed with him. His breath was coming slower, more evenly; the panting had stopped. The stricture was leaving his chest.

"You sure scared me, mister. Thought you were a goner for sure."

"Ah, ah—" he rasped. "You...." He wanted to add more. The words would not come out yet, only garbled vowels.

"Mister, you don't know what a close call you had. I was scared to death to go near you. All I could see is a cop coming on us, me with my hand in your pocket! I'd a been a dead duck. You sure you're all right?"

He nodded. Tears were running into his beard, and he could only nod. As the train pulled in, the man turned, waved and ran toward its doors.

# Tabby

SUSAN FLIPPED THE pages of her notebook, stopped at an empty page and picked up her pen. She remembered that one of her profs had said, when you look at a blank page long enough, you'll write. She had stacked a ton of manuscripts on her typewriter and was too lazy to sort it right now when she had an urge to write...something.

The image of the cat came into her mind again. She wanted so much to write an animal story—dog, cat—loving the furries as she did. But this tabby came to haunt or taunt her. Short-haired mostly and in various shapes and shades. Sometimes long-haired and white, but mostly a bright-eyed gray-and-white tabby would appear and look directly at her.

Sue picked up her pen and for an opener wrote her first line: *The cat climbed up on the chair.* She scratched it. Why begin there? What did she want? Where did she want the cat? She lifted her eyes from the page and there it was on the windowsill at the end of the room. She stared at it. The cat stared back briefly and then busied herself cleaning a paw. Finished, she sat back on her haunches watching Sue.

Sue picked up her pen and shut her eyes for a second when she heard someone speak.

"What do you plan for me?"

Sue's eyes flew open. "Hey! What?"

The cat was looking at her quietly, intently.

Disconcerted, Sue asked, "Who spoke? Must be hearing things." She glanced down at her still blank sheet and began to write *The cat sat on the windowsill watching the birds outside.* As she glanced up the cat was positioned on the windowsill looking outdoors. Sue stared. The cat turned and stared back.

"Is that all I'm going to do? Birdwatch?"

"You're talking?" Sue gasped. I must be dreaming or something. Got to get more sleep."

"You've made me a gray-and-white short-hair. I really would have preferred to be longer haired—black Persian perhaps."

"Why not orange like Morris?" Sue quipped. "If this is imagination—some figment."

The cat preened itself deliberately and answered, "Don't care for TV lights and all that. No privacy, you know."

"But think of all the good food you could have."

"Thanks but no thanks."

"Well, what kind of job would you like?"

"Say, who's the writer? You or I?" The cat jumped off the sill, sauntered into the kitchen and stretched out on the counter nook in full view of Sue's typewriter.

Thinking hard, concentrating on the blank sheet and the cat, Sue offered, "How about an attack-trained cat? Police work."

"Ridiculous." The cat brushed its whiskers. "That would be hard to sell. Too unconvincing."

Sue put the pen on the page. "Valuable lab animal? Important contribution to mankind. How does that sound?"

"Awful. You wouldn't like it either."

"You could be a hero or heroine. Imagine your helping find a cure for AIDS."

"AIDS is your problem, not mine. And don't wish it on us and at the moment I'm a neutered female—at least that was in your mind, if you didn't know it yet."

Sue looked at the page. Two sentences.

*The cat sat on the sill and looked out the window. There was only empty stillness, nothing in sight.*

She looked up at the cat to find its eyes on her. "You're way ahead of me," Sue said. "Why don't you write the story?"

"Me dictate?"

"Why not? We could collaborate."

"Me, a figment of your imagination? You're the writer, remember?"

"So?"

"So you're in control."

"I am?" Sue shook her head. She had heard if you talk to yourself it's all right, it's when you answer, men in white jackets could appear.

"I'm the writer," Sue said half aloud to herself.

"You could make me a real cat," came from the cat.

Sue started. "Real cat?"

"Yeah, a panther. Maybe one of those gorgeous white tigers?"

"No thanks. I'm not writing a jungle story."

"How about a slim sleek cat, Egyptian style? I am related to Isis, you know."

"I'm not writing a 'Twilight Zone' story."

"What role do you want for me?"

How about a children's story? Remember we'll suspend our disbelief..." She wrote *The Pussy lapped up her bowl...*

"Hold it! That word's been scratched. It's only for x-rated and such suggestive you-know-whats."

"What word?" Sue raised her nonplussed face and looked earnestly at the cat.

"Pussy. Colloquially disastrous for us cats."

"Okay. How about pussycat?"

"Better. Passably better, but not great." The cat preened her neck, then stretched out full length and leaned her head on her paws. Sue's eyes flickered between the scarce lean words on the page and the cat's eyes feeding on her— humorously, she felt. She was sure the eyes would crinkle if they could.

"You're not writing," the cat commented from her prone position.

"So what?" Sue was beginning to be irritated.

"Well, there's not much I can do without you. You call the shots."

"Yeah?"

"Yeah. I do what you write. If you're hitting writer's

block, whatever they call that state of inertia writers succumb to periodically, I, of necessity, will be apathetic. It's all right with me if you're happy about it."

. Sue stared at the cat, at her whiskers. "You know you have a Cheshire Cat smile."

"Whoa! That's Lewis Carroll. You better get to your own writing. Why not go directly to the typewriter? It saves you time and you don't have to translate your script. Go to it! Like Grace Paley says, 'tell the story.'"

"How do you know so much? Read a lot?"

"Don't have to. As a figment of your imagination I have access to your data bank."

"Do you have any thoughts about what kind of story I'm to put you into? Children? Adult? Mystery? Sci fi?"

The cat shook its head and stretched out a leg for cleaning. Smoothed its fur. "It's up to you, but better begin that willing suspension of disbelief."

My friends will never believe me, Sue thought to herself.

"Yes, they will," that cat intervened. "All writers are entitled to enjoy their characters vivified—how else can you write convincingly? Right? Look…." The cat curled into a half-ball. "I'll snooze for awhile and not distract you. Write for awhile. Surprise me."

Sue smiled. The cat was peacefully asleep on the windowsill. She cleared the stack of manuscripts and assorted debris off her typewriter, rolled in a sheet of paper, and in bold type in the center of the page typed *Tabby*.

# The Day They
# Ran Out of Doors

"MRS. GINSBERG!" The secretary looked up from her typewriter. "You forgot to add our name to the list. You know, those who attended the temple's fund-raising dinner."

"I'm sorry. I'll be glad to rectify it." Mrs. Ginsberg rose and took the program from Mrs. Margolis's hand. "I'll make a note of that in the next bulletin. I wonder if anyone else was omitted?"

"I don't think so," Mrs. Margolis said. "I checked the rest."

Mrs. Ginsberg sat down at her desk again. Mrs. Margolis remained standing near it. Mrs. Ginsberg looked up at her. Mrs. Margolis had something on her mind. She turned toward the door and then back to Mrs. Ginsberg.

"You know after the humiliation of the other evening, at least I should have my name listed with the other asses."

Mrs. Ginsberg looked puzzled.

Her visitor continued, "Well, the captive audience at our most elegant dinner-dance the other night was forced to divulge the exact amount of their donation—"

"Oh?"

"If I live to be a hundred I will never be so mortified. We always give what we can. When we have more we give more—I know how important the additional school rooms are for the synagogue, but that's no excuse to do that to people. I'll bet the rabbi didn't know anything about it."

"Would you like to talk to him?" Mrs. Ginsberg asked.

"I would. Is the president in?"

"Yes, Mr. Levitz is in the library."

Mrs. Margolis left the office to walk toward the library. She paused at the open library door. Mr. Levitz was poring over architectural plans for the new addition with two other members of the congregation's board.

"I didn't expect him to up his pledge so much," Mr. Levitz was saying as he examined the plans.

Sy Hoffman was drawing in his notebook. "How would this do?" The other two looked at his sketch.

"So, so. Let's leave that to Myron," said Morris Levitz. "Remember we have *four*, not one, additional thousand-dollar donors thanks to your idea."

"Can't complain about that," Sy said.

"I should say not. We could use ten times what we got—but if we only hadn't promised plaques for the doors—" Morris puckered his mouth.

"Don't you think a ruling of the board could substitute a dignified, beautiful plaque in the entryway with everyone's name?" Sy asked.

"No, that wouldn't work. We promised names on the doors. Each donor has the right to have one room named for him." Morris Levitz was self-righteously adamant.

"Say, how about a double door—and a name on each?" Sy ventured.

Levitz looked interested. Sy continued, "Maybe friends would like that. You know the Rogers and the Fryers—the Young brothers maybe would take the kindergarten." He looked at the drawings. "The second grade room is our largest and that's twelve by sixteen. On the sixteen-foot side, I guess a six-foot wide door would be a bit large, right, Myron?"

"I'm afraid so." Myron Furn, the architect, nodded. "Thirty-two inch is average." He measured the blueprint. "Well, we could make it four feet, two on each half; one side alone would allow sufficient entrance and exit for little kids."

"Maybe you should put one on the ceiling?" came from the doorway. They looked up at Mrs. Margolis. "Gentlemen, there must be a place on the sanctuary ceiling to add doors and plaques. The donors would be closer to God. Imagine that." She addressed herself to Morris Levitz. "The prayers would go right up to the big givers."

"Mrs. Margolis, I think we can find suitable places for the doors and the plaques. Leave it to us," Sy Hoffman answered.

"What are you going to do for the little givers like us this year?" she asked.

"There's going to be a plaque honoring the two-hundred-fifty-dollar donors on the wall flanking the gift shop," said Morris Levitz.

"We don't even get into the entry way?"

"The entry way plaques are for five-hundred and seven-fifty-dollar donors."

"You'll have room for us next year maybe—in the entry way—maybe an inheritance will put us on the ceiling of the sanctuary, too."

"Mrs. Margolis, I don't think we'll have to put the doors or plaques on the ceiling of the sanctuary," interceded Sy Hoffman. "We have plenty of wall space yet—"

"But no doors," she said.

"Don't worry, we'll have doors," said Morris Levitz.

"Say," said Sy, "could Myron work out a wall of doors for this exterior wall backing the parking lot?" He pointed to a spot on the plans.

"Maybe you should forget plaques, gentlemen," said Mrs. Margolis.

# And There Was Esther

MALKE MOVISS stirred the prune jam cooking in the pot. Almost already Erev Purim and she hadn't finished the *hamantashen*. One batch was baking and the dough laid out for the other in small rounds on the floured board. Extra special for Morris. Tonight the Megillah would be read in the synagogue and the groggers would spin noisily every time Haman's name was mentioned as the old story of Queen Esther, Mordecai, and Ahasuerus was retold. Round the groggers would spin and other noise makers would clang. A regular din at the mention of the name.

Malke took the jam off the stove and set it aside to cool while she dressed for the evening. Morris was going to pick

her up and she wanted to look her best. She had been seeing him for three years since his wife died. He was good to her—took her to shows, and sometimes to dinner, even drove her to work in his company's laundry truck, when business took him toward her office. The neighbors smiled when he called for her. Malke could see the perpetual question in Mrs. Pfeffer's eyes as she passed them in the hallway, "—Nu, already?"

You can't push a man. Morris spoke not unhappily about his first marriage, but Malke could never be sure. Why the hesitancy when he seemed to prefer her company to others and dated her exclusively, she had no way of knowing or alleviating. She did her best. She dressed as nicely as she could on her income—shopped at Klein's and Orbach's on the Square, kept her weight down by resisting delicious morsels which she knew translated into tight pulling seams, and cooked for him the best recipes she could gather.

She was almost thirty-three, and two wrinkles were beginning to show between her brows, a few appeared on the outside of her eyes, feathering toward the hairline. She had better not worry. It would show more on the outside than inside, on her. A few weeks ago, at a dance Morris had taken her to, an older man, a doctor from the Bronx, had paid attention to her. She had thought of playing this to some purpose, to make Morris jealous or give him a twinge, but the doctor's attention was later taken by a big blonde with heavy makeup. One had to be careful about such things. Morris could be permanently discouraged. But another man's attention might make him more acutely aware of her and force the issue.

She had a nice apartment and a pretty decent secretarial

job, and Mama had left her a little from insurance. Morris could even buy his own truck and get into business for himself instead of being a salaried driver for Deluxe Laundry and Cleaning, Hotels Our Specialty.

Neighbors were sure that something would happen when Morris picked up her laundry, towels, and linens without charge and began putting them through his service. But this was still not reaching a more permanent agreement. It was almost as though he was paying her for meals. Perhaps she was just wasting her time and the precious little of it for getting a husband was going fast. She could just hear Mama saying, "Make him say 'yaye' or 'naye'! What is this going on and on forever like this?" Mama had felt every woman should be married. What else was there in life for her? A man and children, that's all a woman needed.

Malke put on her best black dress, redid the braids wound round her head, and tied a bright scarf around her neck. In the kitchen she filled the rounds of dough with the cooled prune jam, folded and pinched them into the traditional tri-cornered cookies, and set them on a large flat cookie sheet. Into the oven they went. Twenty minutes were all they needed and she would bring them hot and fragrant to the synagogue.

Morris called her from downtown. He had been delayed with an extra large delivery and caught a bite in the hotel coffee shop; she shouldn't wait for him. So she fixed herself a salad and turkey left-overs. There was no need to fuss over dinner tonight. The hamantashen were perfect, she decided as she removed them from the oven. Lightly she pressed the hot dough as she pulled the last batch into the light. Done. Brown and crisping slightly. And smelling heavenly. She set

them to cool, preparing a large paper bag and wax paper. She sampled a cooling triangle. Delicious.

She went into the bathroom to put on her lipstick and eye makeup. Put on her lipstick and blotted it several times with toilet tissue. She didn't like a made-up look. Mama said there was nothing like natural beauty. Makeup was to point up the best of this, not to carry itself like a flag. She applied a speck of mascara after curling her eyelashes. If only Morris could look at her struck like Ahasuerus had been with Esther. But Esther had been beautiful. So beautiful to win the king's heart at a glance. Beautiful enough and good she was too, to save her people. She sighed. How many can be that beautiful? Good. It wasn't so hard to be good. Maybe that was her trouble. She was too sympathetic maybe, Mrs. Pfeffer had suggested, as Malke had narrated to her Morris's aspirations and hopes to have his own company.

"What does he need a wife for, if you give him all your time free?" Mrs. Pfeffer shrugged in annoyance. Advice was cheap, free too.

But the beautiful Esther had been tough also. Tough and hard when she had to be. Could she, Malke, be that way, too? Could she ever say to Morris, "Well, Morris, either— or—?" She would be afraid.

The courage it took Esther to approach King Ahasuerus where he sat in the halls forbidden to women. But Esther was fighting for her people, she had so much at stake. Malke had only herself to fight for. And she was afraid. An ultimatum could scare Morris away. But then her name was Malke, which meant queen. But whether she felt regal enough was another story.

She was putting the *hamantashen* into the paper bag,

separating the layers with wax paper, when she heard foot-
steps on the flight below and heard Morris's voice calling up.

"Are you ready, Malke?"

"Yes! Ready!" she called toward the door. She slipped on
her sweater and checked her scarf and hair quickly in the
mirror before picking up her purse and paper bag from the
table. She looked quite lovely tonight, she thought. Yes, to-
night she would approach Morris as Esther had the king.
With courage and dignity. Diplomatically she would press
the issue. She walked down the stairs to meet Morris on the
landing. As he looked up to greet her, she rushed by him
down the stairs stammering, "Morris, let's hurry and get the
*hamantashen* to the synagogue! They're getting cold already!"

# Sweet Charity

HARLEM. THE walk-up apartment was twenty steps up from the sidewalk. It was badly in need of renovating; there had been no improvements except for emergency plumbing repairs, and none could be expected except for the painting every other year, a hasty job leaving cracks unputtied and covering peeling paint chips with a fresh coat.

Mr. Horowitz had occupied this apartment for forty years. His children had been born here, walked to school from here, married and left here for the nicer sections of town. Mrs. Horowitz had died five years ago and though his children had urged him to give up the apartment and rotate staying with them "for as long as you like, Papa" he kept his

familiar surroundings, watching the neighborhood change as it had over the years.

Stores opened, stores closed. New shops, new owners. Neighbors moved. Gradually the black population which had been on the periphery of this street became its tenants.

When Jake and Annabelle Horowitz had moved in, the street had been mixed Irish-Jewish, a sprinkling of Poles and Italians. A quiet neighborhood. A drug store on the corner, a grocery store in the middle of the block. And for a nickel three delicious kaiser rolls, with or without poppy seeds.

There had been a little shul two blocks down to which Jake would walk Friday evenings and Saturday mornings, even in the snow. Once a *cheder*, a Hebrew school, opened in a store in the middle of the block. They came to him for funds for the cheder which they canvassed the neighborhood and he was pleased to contribute.

"If you need a little more later—next month—I'll add a few cents. Don't be afraid to ask."

The young teacher from the cheder smiled as he unfolded the three single dollar bills neatly into an envelope marked Cheder Beth Tefilloth, and pocketed the envelope with Mrs. Horowitz nodding and smiling at the transaction. This of course while he still worked at the tie factory. Later he had to cut down his donation. But not by very much. He and Annabelle were frugal. They gave to the synagogue. They could always count on his Yom Kippur pledge, and he would get a morning *aliyah*, one of the first to be called up to read from the Torah.

On this day as always Jake walked down to the candy store to get the newspaper. He reached across the counter to pay the fairly new proprietor, a smiling handsome negro

who took his coins courteously and promptly handed back change. "Thank you, Mr. Horowitz." Jake nodded. He missed seeing Mr. Schwartz behind the counter. He and Mrs. Schwartz had managed the store for fifteen, twenty years before selling out and moving to the Bronx. Mr. Horowitz carried the Yiddish *Daily Forward* under his arm, passing the children in the street, ducking between them as the youngsters raced trying to tag each other or coming to a complete standstill when one dashed in front of him to retrieve a misaimed potzi that had fallen in front of his feet. Busy noisy children playing like children, like children everywhere.

As he walked up his stoop, Jake saw a group—two men and a woman—leaving the building. They had boxes in their hands, small metal collection boxes.

"Have you been through the building already?" Jake asked them.

"Mister, we covered all five flights top to bottom," one man answered him.

"I'm in 1D, right here," Jake pointed to his window, which overlooked the right side of the stoop.

The group began to walk down the stairs.

"Three more houses on this block and we're through. My feet hurt," said the tall young woman adjusting a white beret on her head.

"Did—? Didn't you ring on my door?" Jake called the them.

"Sure did. Didn't want to miss anyone," one of the men answered.

"You didn't ask me for a donation? You're selling something maybe?" Jake asked the man who had spoken.

"I, uh—" The man looked at his companions and the box he was holding. He looked at Jake as he continued walking down the stairs, the tallest of the three.

"We really were soliciting only from those who belong to the neighborhood."

"You know—people directly involved," the young woman interceded.

"Is it a worthy cause?"

"We think it is," said the tall younger man thrusting his free hand into his pants pocket as he slowly stepped down the last three steps to stand on the street, and threw a slow apppraise gaze down the block.

"I always give to good causes," said Jake.

The two men looked at each other and at the girl. The tall man snickered.

"Is there something wrong with my money?" Jake walked up two steps and looked into the man's eyes.

"No," the young woman spoke up again, "it's only that we want to do things for ourselves—by ourselves."

"Who said you shouldn't?" said Jake. "Am I an outsider, is that it?"

"Well you see," she went on, "we're collecting money to buy these houses back from the slumlords and put them in the hands of the people who live in them."

"That's nice," said Jake. "So you think I wouldn't contribute to that—I, who live here for forty years?"

"You see, mister," the man with his hand in his pocket interspersed, "we want to get these houses out of the hands of the exploiters...the slumlords," he mumbled under his breath.

"And you don't think I would contribute to that?" asked Jake.

The three solicitors looked at each other, finally the man who had been carrying the conversation with Jake broke the barren silence.

"Why should you?" he looked squarely at Jake.

"Why shouldn't I?"

"You're—"

"You're looking at my beard. I'm Jewish, is that it? You think maybe I'm the landlord? I'm honored. This building is owned by Fedor Lapofski, a Polish Catholic and the next two to us down on this side," he pointed to his right, "are owned by an Irishman, O'Brian."

"We didn't mean that mister—uh," said the young woman.

"My name is Horowitz, Jacob Horowitz."

"Well, Mr. Horowitz," said the more vocal man, "we feel that this area, this section of Harlem should belong to the tenants. We don't like this absentee landlord business."

"It matters to whom you pay your rent?" Jake shook his head, "Not to me—it's not important, as long as it's kept clean, painted every two-three years—"

The man answered again, "It does to us, you see, it's a matter of principle." He spoke into Jake's silence, "People should enjoy the fruits of their labor. Know what I mean?"

Jake looked up at the girl and shook his head.

"We don't want to pad the pockets of rich people to live in fancy neighborhoods," the man added.

Jake knit his brows and shook his head slowly from side to side, "I don't quite understand."

"You wouldn't," said the shorter man, who had been silent until now as he leaned against the metal post on the stoop and shifted his waiting stand from one step to another.

Leaning his hand on his flexed knee he looked up at Jake and said, "You don't belong here—not anymore, you know. You should be with your own people."

"I always thought I was as long as I lived here," said Jake looking down at him.

The girl squatted on the upper step. "My feet, boys, let's hurry it up."

The shorter man put the box down near his feet and looked up again at Jake.

"How come you haven't moved out yet, Mr. Horowitz?" he asked.

"This has been my home for so many years, why should I go and where?"

"The others have."

"You think I should move?" Jake's blue eyes looked at them from under his white eyebrows. His glasses had slid down and he adjusted them on his nose. The three looked up at him. At each other.

Jake continued, "My son Seymour and my daughter tell me I should move, too. For five years they're telling me that. Every Friday night. Whenever they come to pick me up, for dinner, for a weekend, children's parties, I always hear that. My son tells me that the neighborhood has changed. So what stands still? But why should it go down-hill?"

The shorter man looked at the box he had picked up again, "Blacks For Harlem" was printed on one side, "Harlem For Blacks" circled the rim of the other side as he rotated the box in his hand.

"You think I should do what my son says and move?" Jake looked inquiringly at the three, "I really don't like the

Bronx—I like this neighborhood. I've always liked it here," he shrugged.

Jake walked up the last steps and released the Yiddish paper clutched under his arm to turn the knob on the building's door and opened the paper to read as he unlocked his door and walked into the apartment.

# What Friends Are For

"GOOD EVENING, SHMULEK." The elderly man bent over the table to greet a man sitting huddled over his tray, coat still buttoned, the collar drawn up to the brim of his hat, almost covering his face. Shmulek turned sideways in his chair at the greeting, glanced up and smiled wryly as he suspended his spoon in mid-air for a moment, and nodded his friend to the empty chair next to his. Hooking one foot around a leg of the chair, the newcomer pulled it sufficiently away from the table to enable him to slide in front of the chair and set his tray with three dishes and a steaming cup of coffee on the table. He then removed his coat, folded it over the back of his chair, and sat down to

butter his roll before speaking again to his companion, who continued to eat without saying a word or removing his eyes from him.

"You been here long, Shmulek?" asked Adam, and bit into his roll as he looked for the sugar on the table. There was a woman sitting opposite him who, realizing his desire, shoved the chrome-topped glass dispenser in his direction. He nodded his thanks and poured sugar into a teaspoon. Shmulek watched the operation as he continued eating his soup.

"I been here maybe ten minutes, that's all."

"It's crowded tonight," Adam remarked glancing around the cafeteria.

"Yeh. Yeh. But it always is Tuesday night," said Shmulek finishing his soup, putting the spoon down. "You want something else, Adam? I'm going to get more coffee."

"No. Not right now. Maybe I'll have a baked apple. But later. The evening is still young. When you come back, remind me I have something to tell you."

"Sure. Sure," said Shmulek getting up from the table, holding his empty cup in one hand.

"Say, Shmulek, take off your coat and stay a while." Adam laughed at his friend who waved the thought off as he turned toward the food counter.

Shmulek returned in a few seconds. The coffee steamed in the cup he set down on his tray and he reached for the sugar and cream before seating himself in the chair he had occupied before. He stirred the coffee thoughtfully, methodically as though relishing the aroma that steamed up from the cup and the stirring motion. Without looking up he addressed Adam.

"So you have something to tell me, I was to remind you, remember? Shoot."

Adam nodded as he swallowed a piece of bread. He cut a tiny piece of kipper with the edge of his fork and brought it to his mouth. He chewed thoughtfully looking at Shmulek as though digesting the words he was going to expel.

"You know, Shmulek, for years Molly and I have been talking about finding a little piece of property, a rental unit, a duplex—we could live in one apartment and rent the other type of thing. If it worked right our rent would be covered. Right? You know what I mean?"

"Yeh. Yeh." Shmulek nodded vigorously. "A wonderful idea, if you can find it."

After another bite of kipper and roll, Adam brushed the crumbs from his jacket lapels and continued. "Sunday my good friend Sidney Birenbaum called me by phone. He wanted to come right over and tell me about something that had come up. 'Come over,' I said. He sounded so excited."

Shmulek took another drink of coffee. "Excuse me, lady, I need the sugar again." The woman moved the sugar toward him. She smiled at him from under her glasses and tucked a few stray hairs under her striped beret.

"So as I was saying," Adam continued, looking toward the cafeteria's serving counter. "I really shouldn't eat so much. I did so well with Weight Watcher's." He patted his round belly pressed into two billowing sections by a two-inch black leather belt.

"Maybe I'll just stay with the coffee." He eyed Shmulek's dish of scraped clean apple skin.

"So tell me what you had to tell me, Adam. You want me to get you a baked apple, maybe?"

Adam frowned magnanimously and held his palms up. "Enough is enough. I don't want to make a pig of myself."

"Okay. Whatever you say." Shmulek pulled the coffee cup in behind the coat's partly opened collar to meet his mouth.

"Oh, yes. As I was saying...Anyhow, in half an hour in comes Sidney Birenbaum. 'I have a deal for you,' he says, 'like comes up once in a lifetime. You know I have a few little houses in Queens, a couple of little apartment houses— here and there. Well, one of my neighbors wants to sell her duplex. She is getting divorced and quick like a bunny wants to leave her husband and everything she has here. I am over-extended right now or I myself would grab it. Not only that, I am looking to sell all of my little pieces—I am so tired of running to collect rents—some in dangerous neighbor-hoods, that I would really like to get out. But I know you need a little something for the future and it wouldn't take too much to handle, maybe three, four thousand. Perfect for you and Molly. You need something like this. My Shirley's boyfriend's father, Sam Horowitz, is in real estate and he'll show you the place if you like, even this afternoon. Leave it to us and we'll have you on Easy Street.'

"Of course I said yes, After all, what did I have to lose to just look? It seemed like such a good deal...especially from Sidney Birenbaum, a friend for twenty years." Adam picked up his cup, gestured with it, sipped and set it down again, then continued, "So in the afternoon, Molly and me get picked up. Sam Horowitz drives us out to the Bronx in his Cadillac. Comfortable, ah...some car!" He kissed his fingers gently into the air. "We drive, we drive. Through a tunnel, over the bridge, and up over...you know the boulevard going

past the Grand Concourse. Sam is telling us all this time about his little houses. How careful you have to be to buy in the right neighborhoods. 'Neighborhoods change rapidly sometimes,' he tells us. 'You have to be on your toes...have vision and wisdom.' Finally we stop at 4047 Mulvaney. The duplex. One apartment is empty. Sam is disheartened when he hears this from the tenant next door. A nice woman. She lets us in. We look over the apartment top to bottom. Clean as a whistle. Beautiful. Our own place should look so good. Immaculate housekeeper. She has rented that same apartment for three years. The one next door was just vacated Friday, but someone was coming to look at it the next day already. Monday. Sam thought that was very good. The duplex is close to shopping he points out. Three blocks to an elementary school.

"On the way home, he takes us another way. We're checking on the nearby neighborhoods. There could be imminent minority encroachment, he tells us. Collecting rents could be dangerous here, even now he feels. Later there's no telling what. He tells us we're better off waiting for something closer to Brooklyn, to where I work. I tell him it doesn't matter anymore, I'm going to retire in a year. And we passed a shul five blocks from the duplex. I see. We talk. He says the construction is sound and shouldn't run us much in upkeep, repairs, maintenance and all that.

"Painting in between tenants can become very costly, he says, and the turnover in that neighborhood looks to be frequent, he says also. One apartment already would need that kind of care. It would take about five down plus closing costs he figures with his pencil. We can manage, I say, if it seems like a good deal, why not? We'll live like people, enjoy,

and not worry about the rent. 'Once the other apartment is rented, of course,' Sam reminds me. Of course. Maybe I should have had an apple," Adam said reflectively looking over the empty dishes on his tray.

"I'll get you one," said Shmulek standing up.

"No. No. Sit. It'll wait a minute. Sit, Shmulek. I have to finish my story. Anyhow to make a long story short, Molly and me and Sam go back to our apartment and we talk for two, three hours. We have tea, we talk, we figure with pencil and paper. It sounds good, if the lady will take the offer, but I say I would like to sleep on it. Sam shakes his head. He promised to give her an answer that evening. It was already nine o'clock. 'Call her,' I said, 'Ask her if she would mind waiting until tomorrow morning.' I want to talk to an uncle in Baltimore, who knows a little something about real estate, and I would like my friend Howard Heller, who is also a little in real estate, to take a look at the duplex. Sam calls and it's no go. Molly says buy and I say I can't make decisions under such pressure. The lady is hot to get her divorce and leave the country, Sam says. What can we do? 'Buy in haste and regret in leisure' as the saying goes? I can't help it. I'm afraid. I don't want to lose five thousand dollars. Anyhow I don't like to rush into things. We say goodnight. Molly is angry with me, something terrible. I'm a dope. A clod. I have no backbone and I'll never amount to much. Chicken Little here I am.

"That's how we left it that night. I can't risk and she can't wait. We say goodnight. Molly is in a huff. She'll never forgive me, she tells me. Okay, I am what I am, a colossal failure. She keeps telling me this twenty times that night.

"In the morning I'm at work, Sidney Birenbaum calls

Stella Zamvil

me. He and Sam decided together to buy the duplex and give it to the children for a wedding present. Very nice. I wish them and the young people lots of luck. For me he advises a larger unit—six apartments. He'll look for me right away. I hear this and I begin to shake in my Tirebitz shoes with the extra arch support. It must have been some good deal for both connoisseurs to pick up the duplex. Molly will tear her hair when she hears. Worse, she'll tear mine. I leave work with a heavy heart. Sorry that I ever heard about the Bronx duplex, real estate, and all the right ways to get rich. It's just not meant to be for me. Like Molly says, they offered me gold, and I'm afraid to settle for sterling silver. It so happens they're both very high on the market now, but you know what I mean, Shmulek.

"I go home. I'm afraid to tell Molly. Sam's wife, Fanny, tells her at mah-jongg Tuesday night. Did I catch it. I'm no business man, no good provider...eh, on and on. The area is dangerous for me to collect rents, but the children of connoisseur real estators—for them it's fine. So it goes. It was not meant to be for me, that's all. Next time I'll be smarter... maybe."

Adam looked at his empty cup. "Shmulek, can I get you some more coffee?"

Shmulek nodded. He opened his heavy coat with difficulty and reached into his vest pocket for a quarter. Adam declined it with a wave of his hand.

"Some dessert, maybe? Another apple?" Adam asked.

"Eh..." Shmulek voiced his indecision.

"I'll get some for both of us. I want you to hear the rest of the story."

"There's more?"

"Wait. I'll be right back."

Meanwhile two more people had seated themselves at the long formica table. The woman with the striped beret leaned toward Shmulek, "I hope you don't mind, but I couldn't help overhearing your friend. Would you mind if I stayed a minute and heard the rest? I really didn't mean to eavesdrop."

"Sure. Sure. Stay." Shmulek picked up his teaspoon and played with it, tapping it against the base of the coffee cup.

Adam appeared carrying a fresh tray with two steaming cups of coffee and two baked apples which he set down amidst their unbussed dishes. He proceeded to put a cup, a baked apple, and two teaspoons in front of Shmulek and in front of his own seat. He stacked several of the empty dishes on the tray and looked about for an empty table to set it on. A passing busboy pushing a cart of empty trays relieved him of it. Adam resumed his seat, reached for a napkin, helped himself to sugar, stirred some into his coffee. Looked for the cream, poured some into his cup and stirred.

Shmulek watched the operation impatiently. He glanced at the woman, also waiting for Adam's narration. She smiled at Shmulek. He turned his lips up in a smile and looked at Adam.

"Nu?"

Adam looked up at him as he spooned baked apple into his mouth and raised his free hand.

"Right. I must tell you the end. Two days later I get a call from Sidney. 'You know that deal I had, that duplex? Boy, are you lucky you didn't get involved.'

"'How so?'" I asked.

"'The lady came back from Canada, and in the middle of everything decides that she doesn't want to sell the duplex.'

"'She's not getting divorced?' I asked.

"'She is and she isn't. She can't make up her mind. But this offers her some security she says no matter what. So okay we have to return it. What a mess! You should thank your lucky stars you didn't get involved! The bookwork...the lawyer will cost us plenty already and we'll get nothing out of it. But I'll tell you what, he says, since I know how disappointed you and the missus were, first good thing that comes up on the market that I think would suit you, I'll call. Okay?'

"'Okay.' I say. 'You'll let me know.'

"'That's what friends are for, right?' he says to me.

"'Sure. What else?' I say."

"So that was the end of the deal?" asked Shmulek.

Adam nodded yes and sipped his coffee. The woman rose from her chair, smiled at Shmulek as she put her coat on and left.

"Good apple, no, Shmulek? Say, you better take your coat off, at least for a little while—it's getting colder out, and you don't need a cold."

Shmulek nodded and drank his coffee.

# The Woman Who
## Fell from the Sky

THE PLANE DIPPED its wings tentatively and straightened. Fought its way through the darkened milk clouds—thick, heavy, unwilling to give to the glistening metal that swept noisily through, parting them, covered by them. Regina tried to read. She thumbed through the magazine she had brought, tossed it into the empty seat beside her after a glance, and picked up the novel she had attempted in several forays. Troubles of a troubled family, everyday problems, neuroses. She couldn't be held by them.

Turbulence tugged the plane as it fought to keep its

course. The seat belt cut into her with each unexpected lurch. She tried to ease it over her protruding stomach, suddenly aware of the sounds of passenger anxiety vying with the engine noise of the half-empty plane. Crewmen moved from front to back quickly. Decisions had been made in the cockpit to prepare passengers to evacuate the ship.

Each passenger of the Military Air Transport plane was snapped into a chute and given directions for the jump. There were only three women aboard. Two military nurses and Regina, who had done her stint in Korea. One army nurse whimpered, the other wisecracked. They lined up for the jump. Women first priority still held. Women near the door, the men lined up in the aisle behind them. Regina was the first to jump.

"Remember count to ten before pulling the rip cord," floated out to her as the door opened.

Regina jumped. The chute opened. She had remembered to pull the cord. It snapped her backstraps and bounced her into the air suspended over land that appeared. Empty, endless desert. As she drifted down closer, the terrain was rockier, barren. A ridge of mountains in the distance. She swung down, gliding in the ballooned chute. Glancing up she saw the other chutes opening, spinning into the air. The wind was moving her away from them. She drifted toward the mountains. A sudden heavy gust of wind floated her across a narrow chasm in the mountains toward a plain. The down draft pull, the ground closer. She prepared to hit. Roll on your side when you hit ground was one of the last phrases heard from the captain. Let your rump take the thrust of the shock. Regina rolled on the ground, pulled by the chute, until she managed to grip the chute straps and braced herself

to unsnap. A sudden blast of wind tugged the chute and pitched her into the ground. The glasses she had forgotten to remove were knocked from her face by the strap bindings and swept into the chute's billowing folds. Finally the chute lay dormant. She untied herself and lying prone felt for her glasses under the yards of fabric.

Searching frantically she finally located them under the chute and found that the frame had snapped on the bridge. She held them until she realized that she had no pocket for them and slipped them inside her buttoned blouse. She looked around at the landscape blurred to her vision. Which direction to go? A black mass of mountains rose on one side of the clearing. She decided to walk toward the open space that stretched before her.

As Regina trudged the flatlands she began to feel her bruises. A feeling of nausea came up. There was still a twilight warmth in the air. Warmer than she was accustomed to. Her stomach began to tighten, knotting into a hard ball. She had to stop. The cramp relaxed, she breathed and walked on again. The warm wind blew pleasantly from the hills, whichever range they were. Wherever she was. Colorado? Mexico? She trekked on. No insects moved underfoot that she could see in the sparse desert-like growth; no snakes or lizards either. The contractions began again. Painfully hard. She was going to abort. What a hell of a place for this, she thought. The contractions knocked the breath out of her and curled her into knots. She walked slowly when she could and looked for some sheltered area. She passed some tumbleweed-like plants and headed for a cluster of trees that rimmed one side of the plain. She could not determine what lay beyond them. Shapes were too hazy for her eyes. The

periodic spasms continued to hold her motionless until their release when she could again proceed for a few brief interim minutes. The trees were getting closer, and as she approached the cluster, she realized that what she had taken for a clump of trees were rocks. Short mounds of layered rock. Only one tree stood close to a mound. Squinting, she determined its branches against the twilight sky—hazily silhouetted strands rearing from a massive trunk. With difficulty she moved toward the lone tree.

The tearing pains accelerated. Rhythmic, harder, demanding, locked hard against each other. She would eventually expel the fetus. Regina dragged herself toward the tree. The pain kept her from standing upright. It pulled her to the earth.

She braced herself against the heavy trunk, and even thought of trying to squat as women had in primitive societies. Birth stools in medieval paintings. Could use something. Nice clean hospital sheets and anesthesia. An OB to facilitate delivery.

How did this ever happen to her? Chief nurse of pediatrics at San Francisco County Hospital. A career woman. Very successful. Independent. Pretty good looking, considering her age. Fifty isn't old. Not anymore. Not with her body and stamina. Always taken for ten, fifteen years younger. Just flying from the coast to Mexico for an abortion. Cycle had been completely off, misleading with the pill. Ovulations extended. Lord knows she never played games with that. Was it bigger than they expected? God damned pain! Maybe it'll all be over soon. She looked at the darkened sky over the clearing. Rain. Warm. Tropical. Soon the sound of large drops hitting the branches became prominent. They

pounded harder and faster. Thunder. Lightning flashes gashed the black sky.

They'd been drinking a good while when Regina came in. McBradey introduced her around to the uninterested politely drunk. Mouths loosened, ties loosened, some shadowy propriety still observed. A few she had met before nodded without getting up. Jane brought her a double scotch which she swished in her glass and began to sip.

A man who had been looking at her for a long time finally came over. She smiled, expecting him to ask her to dance. He grabbed her and moved toward the dance floor. On the other side of the couches backing the cleared floor were several half-dressed couples fingering each other in the semi-darkness. Men, women, huddled on each other. Regina's dance partner pushed her across the room toward a studio couch. She dance-stepped to keep him in the mood. The physical encounter could wait. Before she could call a halt, before she was fully aware of her partner's intent, he had her down on the couch and was on top of her, peeling through her panties. She screamed. Everyone saw and laughed. Part of the game, just play baby, play. He ripped into her as she pushed against his chest and tried to wriggle out of his grasp. He was finished and out before she caught her breath. A Rabbit—her legs had been spread apart and heat given off. Locked in without will, like a hamster lifting her tail. She got up quickly, pulled her dress down, and said goodbye to the hostel. Eight months ago. No swelling, no nausea, no missed period until three weeks ago.

When the OB examined her he suspected a tumor since

she was still on the pill, but the fetal heart tones were unmistakable. She wouldn't have been too unhappy about this under other circumstances.

Only recently had she begun to think about marriage. Not that she ever really felt lonely. The years had gone by so quickly; her childhood on military posts, her nurses' training after college. Service in Korea. As a civilian her climb to success had been so intense there didn't seem to be time for the required socialization that leads to marriage. Her mother had been distressed with her for years, poignantly so since she turned down her first and last proposal at a "late" thirty-six. Regina hadn't missed marriage. There had been a few doctors on the ward. She loved a few lightly. The others wouldn't leave their families. Tony was especially nice. Just a young resident on her ward.

Regina had seen women dozing between pains. Not like these. She recalled Read's book on natural childbirth and tried to take deep breaths. The pain choked them off. Bear down—get it out sooner. Suddenly she began to expel it, bore down with the pain, the head, the shoulders, the plop of the buttocks. She couldn't move for a long while. Better have a look. Too dark to see. She hoped that she wasn't hemorrhaging. She felt between her legs, a wet rubbery blob, warm yet and moving, a little quiver. She lifted it, could feel head, legs dripping wet. Turned it upside down and hit its back. The baby cried. Regina took off her slip and covered it. Fortunately the rain had stopped and the weather was hot, humid and hot. Birds were making night noises. She held the baby near her and slept.

As the sky lightened she awoke and looked at the little

thing she had cradled in her arms all night. Examined it. A little girl perfectly formed—eyes, limbs intact, the crudely knotted umbilical cord that she had tied in the dark was beginning to dry. The baby was alive. Still alive and sleeping. She put her head near it and slept too.

A cry near her ear awakened Regina. The baby was hungry. She gave her breast to the baby, swollen sore breasts which could give no nourishment for three days, but sucking would ease the baby's pain and bring in the milk. The baby nursed until exhausted and slept at her breast. There must be human life somewhere. People could survive on berries and things. Planes should be looking for them.

Out of the clearing suddenly poured blurred human shapes running toward her. Indians, natives of some kind. They stopped at a short distance from her. Regina was terrified as she spoke to them. To their clothing shapes and colorful faces.

"I'm Regina Harker. Our plane was crashing and we parachuted down—" She made motions with her hands to indicate her descent from the sky.

No comprehension. No response. They looked at her, speaking among themselves in guttural monosyllabic sounds. A woman laughed. Small children moved into the forefront of the surrounding group. They faced her staring. She squinted at a small shape that had moved closer to her, a little boy, she thought. All curious.

Suddenly the chattering stopped. A passage opened in the crowd. Three male figures approached her. They stopped a few feet from her, observed her and then turned to speak to each other. One came very close and addressed her. She smiled at him, at his blurred painted features and not

unfriendly tones. A friendly Indian tribe she hoped. If only she could make herself understood.

"I came in an airplane that crashed. I'm friendly. Can you please help me get word out? Is there a phone nearby? A telephone?" With one hand holding the baby, she lifted the other to simulate speaking on a phone.

The baby began to cry. Embarrassed to nurse in front of the crowd, she tried to calm it by patting it and carrying it back and forth. Recognizing the futility of this, she sat down on the ground and opened her blouse. One of the men moved forward and extended his arms toward her. Surprised by his motion, it was a while before she realized that he was reaching for the baby. She held her closer to her. The baby cried louder. One of the other men sprang forward and tore her arms away from the baby. Regina cried out and ran after him as he put the baby into the arms of a woman flanked by two small children. The men held Regina back as the woman took the baby and walked into one of a group of huts that Regina had mistaken for trees and rocks. She struggled to free herself.

"What are you going to do with my baby?" she screamed. "Give me back my baby! Please give her back! What do you think you're doing?" Her arms finally released, she sank to the ground stunned. There must be someone to reason with. She rose and walked toward the hut into which the baby had been taken, but the way was blocked by men. All had painted faces; yellow, green, and brown streaks across tanned cheeks and foreheads. They held her back. Closer she noticed that the colors were tattooed on the skin. Gently, but firmly she was pushed back to the ground and a bowl of meal placed near her. She was hungry. The crowd had

thinned. From the smoke coming from the huts, she must have disturbed the villagers' breakfast by her sudden appearance. She looked at the bowl and put it in her lap. She had better eat something—they'd find her. Planes probably on their way already. She ate a bit of the gruel-like mixture. Flat, wheaty but edible. She ate fast with her eye on the hut which housed her baby. Suddenly she had to urinate and looked for some privacy. A small clump of bushes not far from where she sat might do. There were a few scattered trees between huts, but no visible sanitary facilities. A very primitive tribe she had no doubt. Urgently, Regina made for the bushes. A few women followed her at a distance. Curiosity or to guard her, she couldn't be sure and didn't care. She relieved herself and saw that for the moment the way to the hut was unguarded. She ran to it, pushed by the door flap and ran in. A man and woman were sitting on skins in the center of the hut. Two small children near them. She looked quickly around the poorly lit hut. A tiny hammock hung in one corner. Her baby. The man, who had risen quickly when Regina entered, jumped in front of the hammock. He pointed to the woman's breast. Regina bent over the women to see better. Dampness in the area of the nipples, a nursing mother.

He took Regina by the hand and pulled her out of the hut. The man then moved her toward a large hut which stood at the periphery of a ring of huts in the village, and indicating the entrance pushed her through into a dimly lit smelly interior. Adjusting to the dimness, her eyes discerned the shapes of several women sitting around a small fire in the center of the hut. Seeing Regina, one of the women rose and pointed out a space near her next to the fire. Regina noticed

when the woman stood close by that she was very old. She tried to thank the woman for her courtesy, but she was already seating herself back at the fire.

Regina, wanting to be by herself, drifted to the back of the hut. As she proceeded to the rear, she pressed close to the woman near the fire, slowly peering down at them. All were very old, very wrinkled even in the dim light. Some still sat erect; others were hunched over, bent into themselves and the animal skins that covered them. Regina found a dark corner far in the back of the hut and lay down to sleep. She was awakened by a touch on her shoulder and opened her eyes to find the old woman who had invited her to the fire bending over her, pointing to the entrance of the hut. There young women, Regina judged by the ease of their movements, were bringing in bowls from outside and setting them near the doorway. The old woman picked them up and carried them to the center of the hut where they sat and ate.

The women spoke but Regina couldn't understand a word. With gestures she indicated that they were eating and invited Regina to eat, too. Her thin finely honed features had their brown, yellow, and green tattoos softened by crisscrossing filaments of wrinkles. A kind colorworn face Regina felt. Features like none of the Indians she had ever seen in that area or in pictures. She would analyze her whereabouts later, for all the good it could serve.

Taking up a bowl she moved toward the group of women who made room for her and sat down near the woman who had wakened her. She put her fingers into the bowl and began to eat. She couldn't worry about poison or drugs. She was their captive and would starve otherwise. Escape seemed

out of the question. She and the baby could never survive the naked terrain alone, without help from a tribe she couldn't communicate with. But surely planes would be scouting for her and other survivors of the plane.

She ate. Chicken. Bland. Cooked without spice. Not too well cooked but cut into tiny chunks. She looked up to find the woman watching her. She smiled and nodded. They nodded and smiled back. She didn't look too different from them she thought. A blonde might have caused more commotion. Goddess and that sort of thing.

Regina finished as much as she could eat and walked out of the hut. The woman who woke her followed closely behind. Regina stalked straight to the hut that housed her baby. Pushing the flap aside she dashed toward the hammock before either the man or woman could stop her. She reached into the hammock for the baby, stooped to lift her and screamed. The baby had been tattooed. The man moved in between her and the hammock and pushed her toward the door. The woman grabbed the baby which had begun to cry and gave her her breast.

"Give me my baby!" Regina screamed. "I can nurse her, too! Look! My milk is coming in!" She tore open her blouse.

Her glasses fell to the floor. She heard them crunched underfoot as they shoved her out of the hut. She collapsed on the damp ground outside the hut and cried. Carried back to the old women's hut, she refused food. She crept back to the baby's hut and sat outside it night after night until the weather turned cold. The old women fed her and substituted leather skins when her clothes wore away. They covered her and moved her indoors when the winter came.

Months passed. The baby began to toddle, but was not

allowed out of the hut when Regina was near. As she was picked up quickly and taken indoors, Regina caught brief glimpses of her. In due time—perhaps five years, the child was tattooed with additional tribal stripes on arms and legs. Regina would still call out to her whenever she saw her.

"Baby girl, please come here—my little baby girl—"

She would smile lovingly as she spoke those words, more and more in half whispers to herself as time went by. The child seeing her would turn and run.

One day a group of children followed the old women as they walked to the stream for water. A lovely spring day. The children called after the women. The women shouted at them and the children laughed. One little one picked up a rock and threw it at Regina. It caught her shoulder. Regina recognized the blurred little shape by its blonde plaits.

Ten years went by, or ten summers or forty seasons. Eat, sleep, walk, excrete, and think from sunup to sunset when sleep closed her mind. She hibernated. Regina could feel the arthritis in her bones. Knobs on her knuckles twisted her fingers; her hands heavily veined stiffened. Her breasts loose, sagged, and the hair as it lay on them white.

Late on a spring afternoon, Regina saw one of the village's young men take a girl into his tent. This was the season of marriages—the mating dances—the few words spoken by the village headsmen. She hoped that the young girl would not be abused. When the blonde head disappeared into a hut, Regina stationed herself on the farther side of the hut. She spent her time sitting there in warm seasons, waiting and watching. In the winters, she was forced by the cold back into the old women's hut, where often inmates did not waken.

Happy to feel warm weather again, Regina took up her nightguard near her daughter's hut. The children, and there was one, then two, ignored her. Even the toddlers bypassed her as a fixture, an appendage of the earth. No acts of hostility, and little friendliness broke the monotony of her days. Each morning she rose to walk to the brook to wash, then to take her breakfast at the women's hut. She understood a few words but seldom spoke. As her teeth loosened and fell out, the gruel and softer meats were more welcome. Her hands were dry and wrinkled, the skin shrunken over the bones; the knotted joints moved stiffly with pain. Her eyelids were heavier and each night as she took her station in warm weather huddling next to the hut, she wondered if her blurring eyes would open to the morning sun. It didn't matter. The rain-fitted rivulets of the fall sent her indoors, as did the hot desert rains until the run-offs dried stipples in the sand. She marked her seasons in confused uncharted sequence.

# Reb Yonkel

R EB CHAIM YONKEL mounted the steps of the apartment house puffing moving his weight from one step to the other. For the fiftieth time he knocked and turned the door latch in response to a call to enter. The books were already spread out on the table and Hymie was already sitting on his usual chair, yarmelka on his head, reading to himself from one of the texts. Mr. Greenberg was standing at the window with his hands clasped behind his back. He turned slowly as Reb Yonkel came in; he nodded for him to sit at his usual seat. He turned slowly as Reb Yonkel made his way into the kitchen. Reb Yonkel took this to mean that Mr. Greenberg was interested in hearing his son

recite that afternoon, so he quickly chose a page for the boy to read aloud.

"Let's begin with the second portion of the *midrash*, Hymie." Hymie had trouble finding his place in the Talmud so Reb Yonkel took it from him, found the page and put it back on the table in front of the boy. Hymie began. Reb Yonkel listened, lifting his eyes from the text every once in a while to look at Mr. Greenberg's face. Mr. Greenberg showed neither approval nor disapproval. He was listening, too. Hymie continued down the page. Finally, Mr. Greenberg broke in, "That's enough Hymie, I want to talk to Reb Yonkel for a few minutes."

Hymie looked at both of them. Reb Yonkel was puzzled. Hymie slid out of his chair and ran into his bedroom, looking as if he understood that his father would rather not have him there.

"Reb Yonkel," said Mr. Greenberg, "the Rabbi listened to Hymie yesterday and tells me that at this rate he won't be able to be bar mitzvahed in June."

"He was never my best pupil, but I think he's okay."

"Not according to the Rabbi."

"I have done my best."

"I didn't say you didn't, but in just a few weeks—"

"We could fill in maybe with another lesson or two a week."

"You're already coming three times a week, and that's already costing a small fortune."

Reb Yonkel opened his hands palms upward and rolled his eyes toward the ceiling. "What do you suggest?" he asked.

"I can't understand why this should happen. We hired you six months ago, and my son is certainly no moron."

"I didn't say he was."

"Then how can this be? By now he should have been well on his way through the *haftorah*. You should have seen that he knew this perfectly by now."

"I can't make him learn faster than he can."

"What do you mean learn faster? He's no dummy. Why shouldn't he know at least the blessings by heart now? A good teacher—"

"Mr. Greenberg are you saying I am not a good teacher?"

"Reb Yonkel, what I am saying is that I can't understand why the boy isn't further along in his studies. By this time—"

"Sometimes he has trouble concentrating. He hears his friends out in the street playing baseball. Sometimes I have to repeat a word ten times before he gets it."

"Couldn't you make it more interesting and explain why he is going through all this—the importance of becoming an adult man in his faith?"

"I have—many times!"

"A good teacher should make his pupil want to learn."

"When all his friends are playing baseball?"

"He has to be bar mitzvahed in only six weeks from this Saturday."

Mr. Greenberg paced the kitchen floor and looked out the window. Reb Yonkel moved in his chair and sighed. He flipped the pages of the *siddur* slowly. Without looking away from the street Mr. Greenberg said, "The boy has been taking Hebrew since he was eight years old. Never did any teacher ever say he was slow or lazy."

Reb Yonkel looked down at the book in his hands and studied the print. He sagged forward in the wooden kitchen chair and with his finger traced an inch of the pattern of the

oilcloth covering the table. He looked down between his knees at the linoleum on the floor, at his aging feet in his worn shoes. He knew the right sole needed repair. He glanced up at Mr. Greenberg's pensive back as he still stood looking out the window at the street below. Years ago he had come to this country with such hope, after all they had come through. He had worked in a tie factory for many years, then sold ices on the streets in the summer, until a few years ago when Morris Simon's son was getting ready for bar mitzvah and the Rabbi of the growing synagogue could not give the boy the additional assist he needed. Someone recalled that he, Reb Chaim Yonkel, a landtzman, a Gredinger Podolier Gebernyer, had had Yeshiva training in the old country and was indeed as well qualified to teach Hebrew as the Rabbi. In truth this was the title he had come from Europe with and poverty had not taken from him, only abbreviated to the colloquial since he was not ordained.

Mr. Greenberg turned back to the room. He met Reb Yonkel's eyes. "He's not a disobedient boy at home. He's good in school, not fresh, not even to his Hebrew teachers."

"He's a good boy," nodded Reb Yonkel. It was true that some you could teach with candy, and others needed an occasional tap of a ruler on the knuckles, especially if they were pointing punk guns at your turned back. Some came straight from public school docilely to the neighborhood storefront *cheder*, others openly reluctant. They came to sit on the wooden benches the landlord had set up. And still the "aleph, bet, gimmel, daled" recitation would float up to the apartment next door or out into the streets during the summer. Reb Yonkel suddenly realized that Mr. Greenberg was talking.

"If my father had only still been here with us, God rest his soul, it would have given him such pleasure to prepare Hymie for his bar mitzvah. Unfortunately, with the store and all, I haven't even had time to listen to the boy. And now this comes as such a shock to me."

"Perhaps, Mr. Greenberg, you should have another talk with Hymie about the importance of bar mitzvah, as you yourself said, of becoming an adult man in his faith."

"Yeh, yeh, I'll do that. But Reb Yonkel, how could you let this go to the last minute and not tell me that he wasn't making any progress?"

"I—six weeks is still good time. We'll try to give him a little extra push."

"There must be no postponement of this bar mitzvah, Reb Yonkel."

"Don't worry."

"I will not pay for extended studies. I hired you with a certain date in mind. You remember?"

Reb Yonkel nodded. He hadn't yet received a check for this past week and hoped that Mr. Greenberg would not need reminding. He watched Mr. Greenberg pull out his wallet, prepare to open it, and suddenly walk across the kitchen toward the hallway, his fingers pinching apart some bills and slips in his wallet. Reb Yonkel watched him select a slightly finger-frayed check from the wallet and pause near Reb Yonkel before he walked into the hallway.

"Hymie! Come in here," he called. Reb Yonkel heard him walking down the hallway to the bedroom. He watched Mr. Greenberg come back quickly and jut his head fiercely out of the window.

"Hymie! Come up here right now! This second!"

He turned back to Reb Yonkel, glared and banged his hand on the table, the check still clenched between his fingers.

"Nu, Yonkel, it's up to you now! Six weeks!"

"We'll get there, Mr. Greenberg. We'll get there." Yonkel sat rubbing his chin with his hand, his eyes glazed on the waiting page.

# Tell Them I'm
# From Brooklyn

LENNY HOROWITZ strapped himself into his seat ready for takeoff. He was actually going. Really on his way. The El Al flight attendant eyed him with efficient brusqueness, checking on the passengers.

"Safety belts, please, everyone." Lenny checked his and smiled up at her. Pretty girl, he thought, but she didn't smile back. Busy. Lots on her mind he was sure. Clearing security had been an exhausting long ritual, but he was grateful for it. He relaxed as the 747 released its jet-rockets and wafted him into the sky.

He had no idea when he came off the stage in the NYU auditorium, diploma in one hand, the other holding his

mortar-board, and felt his parents' and grandparents' arms, that they would greet him with:

"Bubee and Zaydee want to send you to Israel. A graduation present. What do you think?"

What did he think?—Wow! Here he was with a summer ahead in Israel. What news. How had it come about? Seems that his grandparents had wanted to do this for him for a long time. Mom wouldn't listen. He was too young, too weak. But the clincher was his short short story in the college magazine that last semester. He was a writer the family decided and as a writer he should experience the outside world. To become the great Jewish writer they were sure he was, he had to go to Israel. He would write his experiences for all of them to share.

He had majored in sociology with a minor in lit, and just this past semester, in his first attempt at a creative writing course, hit the jackpot. Got A's for both stories and some great comments. One story was grabbed instantly by the editor of the college magazine.

Simple story about a rich yokel from Brooklyn who tries to make it with a chick from the Bronx—sort of a "Goodbye Columbus" in reverse. Yes, he could actually see himself working at this writing bit. He kicked the portable typewriter under his seat to make sure it was still there. It would take him a long time. Years even. He would collect rejection slips by the ton, file them alphabetically and then he would get— the great moment! The first check!

"The draft of your novel is great. Am sending $10,000 advance, registered-special delivery. Hop to it. We want it for the September Book-of-the-Month, too!"

That would be his first. The reviews would hail him as a

young genius—the new Miller-Mailer-Bellow with maybe a little Uris or Roth or Malamud thrown in. The Great American Novel was expected, predicted for him—twenty years in the writing. It wasn't all easy and smooth going. Some of his books were rejected. One or two out of the twenty. His short stories were sought after by *The New Yorker* and *Atlantic* and *Hadassah Magazine*. After his trip to Israel *The New Yorker* turned the entire issue over to his reminiscences—the new slant, as they had for John Hersey's *Hiroshima* in 1946. Yes, the new slant, the human point of view (as only he could write it).

And then when he was eighty—no, sixty—maybe forty... at a great meeting of international writers Philip Roth or Norman Mailer would nudge him and say "I hear you're being considered for the Pulitzer."

"I? Oh, gosh, no. Really?"

"Yes," Mailer would say. "No question about it—you should have gotten it ten years ago. Politics, you know."

He'd sigh and say he knew how things go. Malamud would come over and put a hand on his shoulder.

"Lenny, congratulations. Next year it should be the Nobel Prize for Literature—no, no, don't look so surprised. You deserve it."

His neighbor nudged him at that moment to put down his tray to set his lox and bagels snack on. Dinner would be later. He looked at his neighbor, a Chasid from Brooklyn by his beard and coat. Lenny released the tray in the back of the seat in front of him and it dropped down over his lap. Lox and bagels and cream cheese and onions were served up with coffee. A cardboard carton was served to the Chasid next to him. Lenny watched him break the seal that guaranteed that

the Chasid's meal had been prepared under the strictest su-
pervision of *kashruth* laws. The man nodded to him as he
unwrapped his sandwiches and began to eat. Lenny dove
into his lox and bagels—the onions were tempting, but the
seats were so close together.

He nibbled on his bagel. He was actually on his way. He
knew there were several reasons for his folks being pleased
with his taking this trip. They hadn't been happy about his
dating non-Jewish girls this past year. Felicia, whom he had
been seeing a great deal of lately, was half-Jewish. He knew
the folks were hoping that he'd be grabbed by a gorgeous
Sabra. Maybe he would find a Jewish Sophia Loren type.
That last Miss Israel was some babe—and now the Israeli
Miss Universe—a knockout.

Lenny remembered reading his dad's *Jerusalem Post* that
there was still some discussion about groups settling in He-
bron. He recalled reading about the five murdered Mukhtars
the year before he entered college. It was a troublesome spot
with a bloody history.

He would join a group of homesteading pioneers there.
Maybe he would set up on the fifteenth floor of the Hebron
Hilton. No, that would be too ostentatious, too American.
Maybe a small motel or modest hotel would be more suit-
able for him. He would set his typewriter up there and work,
and in the lovely afternoons hike up to the Israeli *kibbutzim*
off by themselves near a stream. Maybe he'd meet one of the
little kids tending their sheep, and he would explain that he
was an American tourist anxious to help the Israelis and Is-
rael. He'd be standing near the well with the boy.

"Here, I'll help you—let me help with the bucket of wa-
ter. Pretty heavy for such a little guy, isn't it?"

"Oh, no. I do this all the time." An urchin grin spread over the boy's tanned face. A shock of black hair kept falling into his dark eyes and with his free hand he swept it off his forehead, trudging on the sandy ground, grasping the heavy bucket.

"Where do you live?" Lenny asked.

"Over there. On the far side of the palms. See, where my sister is picking dates."

"That's your sister?" Lenny screened his eyes from the sun with the palm of his hand as a vision of chiffon floated into focus—impractical he thought aloud—khaki shorts and military shirt moved through the trees. A hand snipping dates from the low palms. A smile turned toward him and enveloped him. White even teeth and luscious unlipsticked lips—the blonde hair fell softly from her face to her shoulders. It gave her a shy look as the hair half hid her face in a mesh-like veil. She was lovely. Skin slightly tanned. Lana Turnerish. A goddess with a saucy upturned *shickse* nose. She could have played the lead in *Exodus.*

"Hi!" she called and waved to him. She must know I'm an American. My clothes, I bet.

"Shalom," called Lenny.

She wiped her hands on her khaki shorts as he came up to her, and reached out her hand to shake his. It was a lovely cool hand and he held it for a minute.

Chaim, her brother, noticed and winked at him with an all-knowing smile. He was still holding her hand when an Israeli soldier yelled as he ran toward them.

"We may be attacked. Get inside. I'm going to wire for troops."

They ran inside the house, cottage really, and dropped

under a table while the soldier, lying on his back, radioed for help on a small set on the kitchen table. He breathed into the mike a long discourse in Hebrew.

"Directions," the girl told him. Lenny kept looking into her blue eyes. The young Israeli officer was looking at the girl. A paratrooper, by his outfit.

"Ilana," he said to her when he finished the radio message, "we've got to get you and Chaim out of here."

"No, I'll stay," she insisted. "I know how to shoot."

"Oh, no, you don't," Lenny heard himself say. "I'll stay and fend them off—the three of you get going toward the hills. Don't worry about me. I'm an American. I'll just tell them I'm an American who's lost his way on a photography hike. Get going!"

The officer hesitated.

"I can't leave you to face the Arab hordes alone. I'll stay or you come with us—"

"No. You go and take Ilana and Chaim to safety. I'll take your trusted Uzi. Remember when you get there, tell them not to worry. I'm tough, too. Tell them I'm from Brooklyn."

Ilana clutched him. He kissed her as he unclenched her fingers from his shoulders.

"Go! I'll see you in the lobby of the Tel Aviv Hilton, Saturday at 8:30 P.M." He yelled after them—"Don't worry. Tell them I'll take care of things. Remember, tell them I'm from Brooklyn!"

The Chasid jostled his elbow gently as he pointed to the tray a few inches from Lenny's lap.

"Eat it. They'll be taking it away in a few minutes. Dinner is coming soon."

Lenny gulped. Dinner already? Pot roast and potatoes,

with noodle kugel. He'd hardly gotten the bagel down. Ilana was more interesting. He closed his eyes. Tomorrow at this time he would be flying into Lod. The white sparkling buildings would rise up to welcome him. He squeezed his lids together trying to bring Ilana back.

# Mrs. Ringer's Guest

ONE MORNING, two weeks before Christmas, Mrs. Ringer's doorbell rang. When she opened the door, she was very surprised to see a lion on her doorstep.

A note attached to the lion's collar said: "Hi, Mom: this is Mickey. He eats bananas and sour cream, and is very well-behaved. Please take good care of him for me for a few days. Love, Your son, Tom."

"It's a pleasure to meet you, Mickey," said Mrs. Ringer doubtfully. "Do come inside."

Mickey marched into Mrs. Ringer's house like a king. He went straight to the fireplace rug, and with a great yawn, he curled up and fell fast asleep.

Mrs. Ringer dozed off in the armchair as she watched Mickey, her knitting on her lap. When she woke, she realized she was hungry. And if she was hungry, Mickey was probably hungry, too. Did the young lion eat once, twice, or three times a day?

She reread Tom's note. He had forgotten to tell her how often Mickey ate. Dogs ate once, sometimes twice a day. Young puppies ate three or four times a day. She phoned Mr. Jeffries at the pet shop. He wasn't sure how often lions ate. Mrs. Ringer then dialed the San Francisco Zoo and spoke to the caretaker. Their lions were on demand feeding—whenever they were hungry.

O dear, she thought. How would she know when Mickey was hungry? She was fixing a hamburger for herself when she noticed that Mickey had followed her into the kitchen and was looking about, sniffing at the counter. Mrs. Ringer immediately phoned the grocer and ordered five boxes of bananas. She phoned the dairy and ordered ten quarts of sour cream. They delivered them in minutes.

Mrs. Ringer found her huge salad bowl and her old turkey roaster. She filled the bowl with water for Mickey, and quickly peeled a dozen bananas into the turkey roaster and smothered them with sour cream and set them on the floor. Mickey was hungry. He licked the bowl clean.

After lunch Mrs. Ringer let Mickey out into the backyard. What a sweet animal, she thought as she watched the lion admire her plum tree. He might not be too much trouble to take care of. Before she could stop him, he began to rub his back against the tree. It bent and bent and bent. Mrs. Ringer ran out just in time to keep the tree from breaking.

Mickey looked puzzled. He ambled toward the fence, his mane bouncing gently. The fence shook as he rubbed against it.

"No! No! Mickey," she yelled. A lamppost set in concrete or the great old oak tree in front of the library would be a more suitable scratching post for Mickey's four hundred pounds. A walk downtown would be good for both of them, she decided as she wondered what to do next with the lion. But since there was a leashing law for dogs, she felt it wise to put a leash on Mickey. She would have to order one from the pet shop. Extra large. Meanwhile she went to Tom's closet and found one of his old ties and a belt. She slipped the tie around Mickey's neck and tied the belt to it.

"Come, Mickey. We're going for a walk," Mrs. Ringer said.

Hand and leash they marched down the street together. Mickey walked at her side past neighbor's houses, past fences, garages, and cars.

Mrs. Jones, watering her plants, took one look at Mickey and shrieked, "A lion! And it's loose. It should be in a zoo!" She yelled for her son to come inside as she ran into the house and slammed the door.

Her son Alex, mowing the lawn, waved to Mrs. Ringer and Mickey. "A lion! How neat!" He continued mowing.

They passed the mailman delivering mail. He glanced at Mickey and scooted across the street.

"This is Mickey," Mrs. Ringer shouted after him. "He's my son's pet and very gentle." But the mailman was gone. "Oh, Mickey, we're going to have trouble. I might have to keep you locked up at home." She patted his head, "But never you mind, Mickey. They're just surprised to see something

different. You're just not a dog! Let's go home and have dinner."

Again Mrs. Ringer peeled bananas into Mickey's bowl and covered them with sour cream. And again Mickey licked the bowl clean.

When he finished eating, he left the kitchen and curled up on the rug in front of the fireplace again and snoozed. He looked so comfortable, Mrs. Ringer stopped worrying about where to bed him down. Tom's room? The garage? Mickey had found his own bed.

Mrs. Ringer picked up her knitting and watched television with Mickey.

After breakfast the next morning, with Christmas coming so soon, Mrs. Ringer realized that she wanted to buy Tom a shirt. Ready to leave, she picked up her purse. There at the door sat Mickey with his tie-leash in mouth.

"All right, Mickey, you're coming with me. We'll get Tom his Christmas gift together."

The clerk in the store looked askance at Mickey.

"Never you worry," said Mrs. Ringer. "He's gentle. He doesn't even roar or bite."

The clerk brought out shirts for Mrs. Ringer to chose from.

"Do you like the blue or the green plaid for your son?" the clerk asked. "They're very popular."

"Both are lovely," commented Mrs. Ringer. "Mickey, which do you think Tom would prefer?"

Mickey walked over to the blue shirt and nudged it with his nose.

"Thank you, Mickey," Mrs. Ringer said. "We'll take the blue. Would you Christmas wrap it for me, please?"

The clerk wrapped the shirt and put it into an elegant shopping bag. Before Mrs. Ringer could lift it, Mickey took the handles in his mouth, ready to follow Mrs. Ringer.

"Mickey!" Mrs. Ringer smiled, and patted the lion's head. "You're a real gentleman! I don't know what I'm going to do without you!"

On their way home, they heard a woman screaming, "My baby! My baby!" Down the street a stroller careened heading for the trafficked intersection. Mickey dropped the bag, sprang across the street and, stretching his body full length, leapt toward the stroller. With his teeth he gripped its handle, stopped the stroller, and sat waiting for the baby's mother and Mrs. Ringer to catch up.

The mother grabbed her baby and hugged it to her, and with one hand kept patting Mickey's head. Mrs. Ringer was so proud.

When Mrs. Ringer and Mickey approached the bank they saw a crowd clustered near the entrance. Two men holding bags of money and guns threatened the crowd. With a mighty roar, Mickey dashed toward them, dragging Mrs. Ringer along. Mickey sprang and pinned the thieves to the ground. The police arrived and thanked Mrs. Ringer and Mickey for their help. Everyone praised and patted Mickey. He had saved the bank.

Two days before Christmas a letter came from Tom saying that a van would be picking up Mickey the next morning. When she read the letter Mrs. Ringer wrapped her arms around Mickey's neck and hugged him.

The next day Mrs. Ringer and Mickey got up early and waited for the van. Nine o'clock passed. No van. Ten. No van. Noon passed and the van still hadn't arrived. They had

lunch and rested. Mrs. Ringer kept looking at the clock and petted Mickey's mane.

"They'll be coming soon, I'm sure," she said. "I know you'll be very happy to be back with Tom. He must miss you terribly." She leaned over Mickey and hugged him. "I'm going to miss you terribly, too." Then she cried quietly and Mickey licked her tears. She wished so much that Mickey could have stayed through the holiday, but the van was coming.

It was beginning to get dark outside and Mrs. Ringer wondered if Tom had made an error in his letter and Mickey would not be leaving that day.

Suddenly the doorbell rang.

"That must be the van, Mickey, to pick you up," said Mrs. Ringer. She stroked Mickey's back as they walked slowly to the door. Sadly she opened the door.

There stood Tom!

"Hi, Mom! How are you?" said Tom. "Cat got your tongue? How about a hug and a kiss?"

"What are you doing here, Tom? We were expecting the van to pick up Mickey. We've been waiting all day."

"Well things got done faster than I expected. I thought I'd like to spend Christmas with you and Mickey. And besides I wanted to know if you liked the Christmas present I got you." Tom patted Mickey's head and smiled.

Mrs. Ringer hugged Tom and Mickey. "I love holiday company," she said.

# Go and Begone

MYRTLE SMOOTHED her print dress over her hips as she stood in front of the door. She looked at the well-kept lawn edged with a tightly cropped border of orange zinnias. Trim. Neat. Lovely, peaceful and colorful. She turned her attention to the door with only its austere brass nameplate to adorn the varnished mahogany surface.

"Mrs. Leona Ridder."

Myrtle rang the bell and stood nervously measuring the seconds with foot taps of her high-heeled bone sandals. Finally footsteps, the doorknob twisted, the door opened and Mrs. Ridder's tightly bunned dark hair and long nose appeared through the narrow opening. Her sharp features sharpened into a polite smile as she recognized Myrtle.

"I've been expecting you. Come right in." Mrs. Ridder opened the door wide for Myrtle to slip through and closed it behind her. Myrtle looked to embracing her, but Mrs. Ridder turned quickly and business-like led Myrtle through the living room into her private counseling office. The small room panelled in warm wood was neatly appointed with two small maple armchairs and a small round pedestal table. Myrtle took her usual chair flanking the narrow brick fireplace. Mrs. Ridder smilingly moved her chair closer to Myrtle's and sat down facing her.

"Do you feel better after last week?"

"Oh, yes, much," Myrtle answered settling her ample buttocks into the dainty caned sidechair. "Well, really, sometimes I'm not sure."

"But you are much better, Myrtle. I feel a lightness about you. You're going to be all right."

Mrs. Ridder clasped her hands together in her lap and closed her eyes.

Myrtle fidgeted slightly, ran her hand over the flowered print of her dress pinching a pleat into place. She watched the other woman's bosom rise and fall under her gray cotton shirtwaist. What terrible taste in clothing Mrs. Ridder had, but then she was more concerned with otherworldliness. Myrtle sighed and crossed her ankles.

"I do hope I'll be all right, Mrs. Ridder. It's at night that it's real bad. That's when I see him most. And I can't stop crying...feel so bad." A sob stopped in her throat.

Mrs. Ridder opened her eyes. "That will pass. I will continue to work with you and we'll ask the Higher Powers to make it easier. Remember Will will be with you, whether you see him or not. You must learn to think of him in the

larger framework of which we are all part—not in the human shell. You must let him," she emphasized in a dull staccato tone. "Let him drift back to where he belongs now. Eight months is too long." The monotone continued trancelike. "You're only making the both of you unhappy." She leaned back in her chair and closed her eyes again.

"Do you want my ring, to tune me in?" Myrtle asked removing the diamond ring from her plump finger with some difficulty. She extended the ring.

"No, no." Mrs. Ridder answered without opening her eyes. "I can tune you in without it." Slowly she recited in solemn tones, "Our Father, we give thanks for Myrtle Greenwood, for her being and her goodness. For her pleasing form and perseverance. for the kindness that exists in her heart and her desire to be good, to do good for her fellow beings."

Myrtle squeezed her hands together tightly, watching Mrs. Ridder's face. The voice stopped. The face closed. Her breathing was shallow. Myrtle began to feel anxious. Would the psychic ever finish and open her eyes? After long moments the voice continued. "We ask you to lift her to the light and see her through this difficult time. Amen. Amen. Amen."

Slowly the eyes opened and, staring sharply from the gaunt face, looked at Myrtle. Myrtle stared back fidgeting childishly in her seat.

"Did Will say anything last night? Like he did a few nights ago?"

Myrtle shook her head no.

"He spoke the night before you said."

Myrtle nodded and fiddled with a loose blonde lock that had disengaged itself from her carefully coiffured head.

"He did. He made sounds but it was garbled."

"He never spoke too much at any time, you said, just kept repeating a phrase very softly..."

"Yes. Over and Over, 'Myrtle. Wait. Wait.'"

"Did he try to communicate again last night? Any sounds or motions?"

"No." She thought intently, frowning past the woman, her eye catching on a plant in the corner of the room. "He just looked." She stared at the philodendron as she tucked the rebellious curl tightly under the hair behind her ear. It sprang out again wobbling saucily against her round pretty face.

She looked up to see Mrs. Ridder's eyes hard on her.

"How did he look?"

"Like he always does." Myrtle tried to glance down at her wrist without being obvious. Four o'clock. Still daylight. Was she to pick up Frieda for mah-jongg or vice versa? Mrs. Ridder's eyes were closed when she looked up. She glanced again at the philodendron in the corner. Wilted. She would ask about it. Underwatered? Couldn't be. Fungus perhaps. Mrs. Ridder was so careful about her plants. Her babies, she called them. The room was silent. Myrtle could hear her own breathing. Suddenly she felt chilly and wished she had brought a sweater. Mrs. Ridder was so quiet again. In trance perhaps. Then Mrs. Ridder's lips moved. Without opening her eyes, she asked.

"Do you think that Will was trying to speak?"

"I don't think so. I don't know. Couldn't really tell." Myrtle fussed with the edge of her dress, smoothing the hem against her leg.

Again the lips moved. "Was he sad or smiling?"

"He looked a little tired and...well, maybe he seemed... angry."

Mrs. Ridder opened her eyes. "How was that? What made you think he was angry?"

"I'm not sure. He just stood there, like always, and looked. Kept looking at me, and then opened his mouth once in a while—it was almost funny...like he wanted...." Myrtle half giggled at what she was going to suggest. "...like he wanted to bite...especially when he saw me phone you and we were talking...."

Mrs. Ridder was puzzled. She frowned, heavily pondering Myrtle's last observation.

"He looked hostile?"

"Hostile?"

"Angry. Mad."

"No...well, maybe...." Myrtle knit her carefully pencilled brows. "He never used to look at me that way when he was alive." She looked up questioningly.

Mrs. Ridder seemed to get angry for a moment, then leaned forward and raised her hand soothingly. "It will be all right, you'll see. These cases are a little harder to work out, but they do...eventually. Remember, *you* must try harder to let go! You must relax your will. Your unconscious will to keep him with you is causing this. Let go! Let go!" Her eyes closed. She swayed in her chair.

"But I don't know how to let go," cried Myrtle shaking her head. "I really don't know how. I don't know what I am doing wrong! I don't know what you mean when you tell me that I might be one of those that doesn't let people die!" Myrtle's large blue eyes filled. "I can't help what I feel...."

Mrs. Ridder opened her eyes and stared at her.

"Let us pray together and we will ask for help. I once heard of a case where a mother could not release her dead child. Neither could rest. It took months of prayer before the bond was cut. Let us hope this will not go on any longer for you." She closed her eyes and murmured to herself for a few moments, and then out loud spoke:

"And so Father, bring peace to the departed soul, William Greenwood, and aid Myrtle in finding the way to release his spirit from this earthly bond. Ease him from her presence, O Lord, so he may partake of Thy heavenly rest. Lift these two unto Your light. Amen. Amen. Amen."

Silence hung heavily in the room. Myrtle shivered goosebumps. Mrs. Ridder opened her eyes and smiled. The mouth smiled. Her eyes stared pointedly into Myrtle's, almost a little angrily, Myrtle thought. Perhaps she felt that Myrtle wasn't working hard enough to unburden herself, as if she had asked for this...Perhaps it was just her imagination. Wasn't she paying her enough?

"Is twenty dollars still all right?"

"That will be fine, Myrtle. Thank you." Mrs. Ridder nodded still smiling at her.

Myrtle opened her purse, deftly extracted two ten dollar bills, and offered them to her.

"No." Mrs. Ridder waved them aside. "Just put it on the table, please. Thank you, Myrtle."

Myrtle laid the bills on the small round maple table between their chairs. Withdrawing her hand she noticed her fingers had left a trail in the light film of dust on the table. Mrs. Ridder must be very busy or preoccupied. So unlike her meticulous housekeeping habits. A cleaning girl would help. Myrtle glanced at the two tens again. It would be

good, too, if she would get herself another outfit. She was getting tired of seeing her in that same drab housedress. She had been paying her enough, after all this time, to buy her a couple of smart outfits. She avoided looking into Mrs. Ridder's face for a moment. What if the woman were a mind-reader as well? Myrtle got up quickly and walked out of the room. Mrs. Ridder followed her back toward the front door. Enroute Myrtle paused in the living room and turned back to her.

"You will be able to help me, won't you, Mrs. Ridder?"

"Of course. Do you doubt me?" Mrs. Ridder's eyebrows bristled into the bridge of her nose.

"No. No. It's only...it's only taking so long."

"One must be patient when one deals with the eternal. You were not in such a hurry last week. Something has changed?"

I...well, one should go on living. You told me this yourself right after...."

"Yes. Yes. One does have to pick up the pieces of a life and continue. There seems...." Mrs. Ridder frowned momentarily, then continued. "I promised that I would take care of you and I will, don't worry."

Myrtle turned to her once more as she opened the door to let herself out. Repentant, she asked, "May I come sooner than next week, if it would help, Mrs. Ridder? I feel so much better after I've talked with you."

"Why not wait and phone me? Perhaps things will ease and you won't have to see me so soon."

"Thank you. You're such a help." Myrtle stepped through the doorway and pivoted to say a quick goodbye. Mrs. Ridder was already gone.

At home Myrtle sat down to enjoy a cup of coffee with the newspaper she found on the driveway after parking her car. There was still time to phone Frieda. She'd fix herself a light snack according to her Weight Watcher's schedule, and look over the department store ads as she ate. She moved deftly in the kitchen, deliberated on a piece of cake and decided against it. She was not going to cheat. Two pounds in a week and her waistline was looking trimmer. Timothy Johnson had given her a hug that morning at the office. Couldn't take him very seriously though, unfortunately. He was a known ladies' man.

The clock in the living room struck six. No Will yet. This was his usual time to come home from work, when he'd saunter in and pinch her cheek or bottom, whichever presented itself. Myrtle held her breath. Maybe this time it had worked, like Mrs. Ridder said it would. Yes, maybe this time...after all those months. She smiled to herself. Now she was free. She poured herself another cup of coffee and put a bit of milk in it. Real milk to celebrate. Liquor had too many calories, and she wanted her waistline back.

Myrtle read and nibbled on grapes for a while, then checked her watch again. Six-thirty. No Will. She felt jubilant. Gone for good. She would call Frieda and tell her that she would pick her up for mah-jongg. But first she should call Mrs. Ridder. She folded the newspaper neatly and tucked it on a chair with the throw-aways that she collected every day. Suddenly she felt cold. She looked up. Will was standing near the kitchen counter smiling at her. Her heart chilled. He beckoned her with his hand. Frightened, slowly she followed him. He moved into the living room. In the soft hazy summer twilight, as the sun's last beams came

through, he glided through the glass door, stood on the other side smiling for a moment and slowly faded.

Myrtle gulped in relief. Perhaps now she was totally free of Will. Perhaps, now. She'd phone Mrs. Ridder for an explanation. Quickly she turned back to run into the kitchen when her eyes spun over the living room. She gasped. In the rocker sat Mrs. Ridder, rocking and smiling.